Translated from the French
by
Judith Landry

Smarra & Trilby

with an introduction
by
John Clute

DEDALUS

Dedalus would like to express its gratitude to the French Ministry of Foreign Affairs for its assistance in producing this translation.

Published by Dedalus Ltd, Langford Lodge, St Judith's Lane, Sawtry, Cambs, PE17 5XE

ISBN 0 946626 79 0

Distributed in Canada by Marginal Distribution, Unit 103, 277 George Street North, Peterborough, Ontario KJ9 3G9

Distributed in Australia by Peribo Pty Ltd, 26 Tepko Road, Terrey Hills, NSW 2084

Translation & Introduction copyright © Dedalus 1993

Publishing History
First published in France 1821/22
Dedalus edition 1993

Typeset by Cygnus Media Services, Redhill, Surrey, UK
Printed in Finland by WSOY

DEDALUS EUROPE 1992–1995
supported by the European Arts Festival
July–December 1992

EUROPEAN ARTS
FESTIVAL
JULY-DECEMBER 1992

At the end of 1992 the 12 Member States of the EC inaugurated an open market which Dedalus has celebrated with a major programme of new translations from the 8 languages of the EC. Dedalus has now extended this programme to the whole of Europe, and by the end of 1995 will have published something from almost every European language. The new translations will reflect the whole range of Dedalus' publishing programme: classics, literary fantasy and contemporary fiction.

From Danish:

The Black Cauldron – William Heinesen

From Dutch:

The Dedalus Book of Dutch Fantasy – editor Richard Huijing

From Dutch / French:

The Dedalus Book of Belgian Fantasy – editor Richard Huijing

From French:

The Devil in Love – Jacques Cazotte
Angels of Perversity – Remy de Gourmont
The Dedalus Book of French Fantasy – editor Christine Donougher
The Book of Nights – Sylvie Germain
Night of Amber – Sylvie Germain
Days of Anger – Sylvie Germain
The Medusa Child – Sylvie Germain
The Weeping Woman on the Streets of Prague – Sylvie Germain
Monsieur de Phocas – Jean Lorrain
Le Calvaire – Octave Mirbeau
Smarra & Trilby – Charles Nodier
Monsieur Venus – Rachilde
La Marquise de Sade – Rachilde

From German:

The Angel of the West Window – Gustav Meyrink
The Green Face – Gustav Meyrink
Walpurgisnacht – Gustav Meyrink
The White Dominican – Gustav Meyrink
The Opal (and other stories) – Gustav Meyrink
The Dedalus Book of Austrian Fantasy: The Meyrink Years 1890-1930 – editor Mike Mitchell
The Dedalus Book of German Fantasy: the Romantics and Beyond – editor Maurice Raraty
The Architect of Ruins – Herbert Rosendorfer

From Greek:

The History of a Vendetta – Yorgi Yatromanolakis

From Italian:

Senso (and other stories) – Camillo Boito

From Polish:
The Dark Domain – Stefan Grabinski
The Dedalus Book of Polish Fantasy – editor Wiesiek Powaga

From Portuguese:

Lucio's Confessions – Mario de Sá-Carneiro
Short Stories – Mario de Sá-Carneiro
The Mandarin – Eça de Queiroz
The Relic – Eça de Queiroz

From Russian:

The Dedalus Book of Russian Decadence – editor Natalia Rubenstein

From Spanish:
Misericordia – Benito Peréz Galdós

Pan European Anthologies:

The Dedalus Book of Surrealism – editor Michael Richardson

THE TRANSLATOR

Judith Landry was educated at Somerville College, Oxford where she obtained a first class honours degree in French and Italian. She combines a career as a translator of works of fiction, art and architecture with part-time teaching at the Courtauld Institute, London.

For Dedalus she has translated Giovanni Verga's *The House by the Medlar Tree* and Jacques Cazotte's *The Devil in Love*. Her current projects include translations of the Sylvie Germain novels, *The Weeping Woman on the Streets of Prague* and *The Medusa Child*.

Contents

INTRODUCING CHARLES NODIER

Charles Nodier was born in 1780, just as it was beginning to become clear that the Ancien Régime had a false bottom. He died in 1844, in Paris, having lived through a succession of governances of the world, each of which had dissolved in turn, exposing another false bottom to reality. He was briefly imprisoned in 1803 for publishing a rhyming pamphlet satirical of Napoleon, but generally eschewed active politics. He became a man of letters, and during the course of an industrious life published much fiction, an 1820 melodrama about a vampire, histories, bibliographies, studies in entomology, much else. If he was a significant figure in early French Romanticism (as indeed he was), he was significant in part for his literal embodiment — from 1824 to his death he was librarian for the Bibliothèque de l'Arsenal — of the essential *bookishness* of the movement.

At the Bibliothèque, Nodier soon established a kind of male salon or 'cenacle', frequented by fellow devotees of Romantic sensibility, including Alfred Vigny, the Deschamps brothers, Victor Hugo and Charles Sainte-Beuve. The tradition of the cénacle — the term means upper chamber, with specific reference to the room used for the Last Supper — could not be described as expressing any revolutionary confrontation with the world or the world's politics. Nor did the cénacle — though both Hugo and Sainte-Beuve later convened their own versions — generate any notable Romantic doctrines. One supposes that it may best be described as an affinity group, structured around the 'discipleship' of its invitees, and focused on appropriate

aesthetic responses to a singularly insecure world. Nodier was himself perhaps the ideal guru for a conclamation of men of books. He was a man of skills, with a fresh and invigorating mind, but not dangerous to know. His fiction was much admired. But it was not dangerous.

Or so it has seemed. One hundred and fifty years after his death, none of his adult fiction had yet appeared in English, or so it is easy to believe. Nodier has become a footnote in literary history, and the unavailability in English (till now) of any of his mature fantasies once again demonstrates the sidebar status still allotted to non-mimetic literary genres as they developed during the nineteenth century. If not forgotten entirely, authors of non-mimetic fiction tend to be demonized, dismissed as artists manqués, or trivialized as writers for children. Nodier was clearly neither a demon nor a manqué, but it is interesting to note that before 1993 only two Nodier fictions were published in book form in English, and that both *Trésor des Fèves et Fleur des Pois* (translated 1921 as *The Luck of the Bean-Rows*) and *Le Chien de Brisquet* (translated 1922 as *The Woodcutter's Dog*) were released in formats ostensibly designed to appeal primarily to children.

On examination, this seems slightly odd, certainly when one looks at *The Luck of the Bean-Rows*, whose cover proclaims it 'a fairy-tale for lucky children', but whose structure and style make it very close kin indeed — though shorter and simpler in its compass — to the two short novels now finely translated by Judith Landry. *Smarra, ou les Démons de la nuit* (1821), here given as

INTRODUCING CHARLES NODIER

Smarra or the Demons of the Night, and *Trilby, ou le lutin
d'Argail* ['Trilby, or the Imp of Argyll'] (1822), here
presented simply as *Trilby*, are two full-fledged tales
from Nodier's prime, sleek and flowing and highly
unsafe. What is interesting is how precisely the smaller
fable encapsulates the techniques and the *dangerousness*
of the longer ones. *The Luck of the Bean-Rows* is an ideal
lesson in reading Nodier.

 Once upon a time an old man and his wife
discover a tiny child in their bean field, christen him
Luck of the Bean-Rows, and raise him as their own.
From the moment of his arrival, good luck glistens
through their lives, and their bean field grows — with-
out impinging on neighbouring fields — until it has
become a flourishing plantation. Soon it becomes time
for Luck of the Bean-Rows to make his first journey to
the big City. The old man and his wife give him three
pots of precious beans to do with as he wishes, beg him
to return before nightfall lest they die of anxiety, and he
leaves. As usually happens in fairy tales, three suppli-
cants beg him for help en route. The first two are
worthy, and he gives them each a pot; the third is a
patently disingenuous and smarmy wolf, but Luck gives
him a pot as well. He then comes upon Pea-Blossom,
whose carriage — a chick pea — proves magically large
enough to carry him round and around the world at
great speed just after she tells him she has decided on
a marriage-partner and gives him three gifts. Years later
— though the time has passed as though in a dream —

11

the great steam carriage finally halts in a desert land, which Luck transforms with his three gifts from Pea-Blossom into an Eden. The wolf and its minions fail in their attempt to invest the great palace. Luck sees in a mirror that he has become a man. He grieves for his parents, but after more profound slumber awakens to see that the bean plantation has been incorporated into Eden, the old man and his wife fall into his arms, as does Pea-Blossom, now a young woman, who welcomes them inside. "'This is your son's home,' she says, 'and it is in the land of the spirit and of day dreams where one no longer grows old and where no one dies.' It would have been difficult to welcome these poor people with better news." They live happily ever after.

The utter strangeness of this fable lies not in any one magical ingredient, nor in any of the characters involved: for they are of common currency.

The strangeness lies in the shape of the thing itself. As each fragment of the tale ends, we undergo a dream-like non-sequitur *shift* into the next fragment, as though Nodier had opened a false bottom in the world and dropped us through. Some elements of the tale may be retained through various shifts (the wolf, for instance, but not the previous recipients of Luck's gifts), but their re-entry into the story will be conveyed with a sense of oneiric discontinuity. It is as though (like the reader) they fall deeper and deeper into the entrails of the dream. And, at the end, there is an epiphany. Through it, Nodier may be claiming to announce the triumph of

Faerie; but (like the Faerie of significant fantasy writers from Lord Dunsany through John Crowley) Nodier's Faerie bears a strong taste of death.

The Luck of the Bean-Rows is written, as one might put it, in clear. It is a fairy story. But it is not children's fare: not in the precariousness of the realities it depicts; not in the hints of sexual subtext that well upwards whenever Pea-Blossom offers to split the vertical smile of the lining of her pod; not in Faerie as a Kingdom of Death. But because it is so clear, and perhaps because it lacks the *liebestod* intensity of the two mature works, it is a perfect introduction to *Smarra* and *Trilby*. This is not to say that either of these tales is merely a *Luck of the Bean-Rows* written in code. They differ in other ways as well. In both of these tales of profound entrapment, Nodier's language — in its metaphoric density, and in unrelentingness of its attempts to make higher reality visible through the mists of night — conveys an almost visceral sense of the coils of dream. And both tales differ in another way, as well, from the fairy story. Both are deeply imbrued in learning. Each of them is a book through which other books dream.

Smarra in particular is studded with allusions, some opaque, some fairly clear, some perhaps no more than wrong turnings in the labyrinth. The story is, perhaps, simple (if *Tristram Shandy* is simple). A young man named Lorenzo — long banned by the evil tricks of genies from gaining his beloved Lisidis — lies beside her in the bed which had been the site of so many dreams: visions of Apuleius, for instance, whose *Golden Ass* is a fable of transformation which contains within it further

fables, a tale of unending night which lightens only when Lucius, the sorcerer's apprentice, is changed back into human shape through supernatural intervention. But now Lisidis sleeps beside him, and he himself begins to drowse downwards into a land of swarming pollen, will-o'-the wisps, and Dream.

The next chapter drops us into the heart of Thessaly, where a young man named Lucius rides his great horse Phlegon towards Larissa, where sleep awaits him, but before arriving finds himself tumbling through false bottom after false bottom of the forest world downwards into scenes of Miltonic gloom, where Polemon — who had saved his life in battle — tells of his anguished entrapment in convoluted routines of sexual torture. Soon Smarra — a metamorphic demon of sleep and dream — intensifies his torments. He stops telling his tale, somewhere from an indecipherable end. Lucius himself topples deeper into bondage, the language of *Smarra* becoming almost dementedly sensitive to paroxysms of allusion — perhaps like all dreams of the lettered, Nodier's dreams reek of reading — and damnation. Finally he comes to the central scene. He is on a battlefield. Polemon has saved him. But he is dead. He awakens. He is Lorenzo, we have escaped the nightmare of Apuleius and all the host of Milton and the imps of Shakespeare and the house of mirrors of Sterne and the fret of Byron, and Lisidis is by his side. She will remain by his side. But a slight perturbation chills the world of the book once again. 'Are you asleep?' she asks. Who is dreaming?

Less convulsed, but no less transfigurative of the

realities it begins with, *Trilby* is set in Sir Walter Scott country, the county of Argyll in the western Highlands, at some undetermined point in the past. Trilby — the name is quite astonishingly unfortunate to modern ears — is an imp who is in love with Jeannie, a ferrywoman and wife to Dougal. Rather like Luck of the Bean-Row, Trilby infuses the life of Jeannie and Dougal with an edenic glow; but the intervention of strict Christian doctrine bans him from the hearth. Jeannie's own gradual realization that she has become enamoured of the imp, whose flickering visage becomes intermixed — perhaps only in her mind — with that depicted in a mysterious portrait hanging in a gallery in the great monastery, to which she and Dougal have gone on pilgrimage, seeking a return of wealth, a home in Eden once again. Back on the barren loch, her entrapment becomes more severe, and another dance of dreams and death is enacted, like a sorcerer's joke, against the meticulously conceived backdrop: for the course of the *liebestod* dance could be traced upon a map of Scotland.

If dreams are woven out of quotes, so too are *Smarra* and *Trilby*. Entering either tale is like falling volitionless through the shelves of the Library of Babel, tickled by unending echoes. There is a sense of belatedness to Nodier, as though his works proclaimed a feast just now abandoned by the carriers of dream: the heroes and heroines, the demons and imps and temptresses and dark lords who populate the fables of the Western world. Nodier is one of the first fantasists of the belatedness of dreams. He is one of the first to insinuate hints — slyly, from the embonpoint seclusion of his

cénacle — that the West itself had become a congeries of dream in the library of the Golden Age. His stories are glimpses into that library.

John Clute, November 1992

SMARRA OR THE DEMONS OF THE NIGHT

Somnia fallaci ludunt temeraria nocte,
Et pavidas mentes falsa timere jubent.
(Dreams, in deceiving night, make sport of us,
troubling our souls with non-existent terrors.)

Catullus

... The isle is full of noises,
Sounds and sweet airs, that give delight, and hurt not.
Sometimes a thousand twangling instruments
Will hum about mine ears; and sometimes voices,
That, if I then had wak'd after long sleep,
Will make me sleep again: and then, in dreaming,
The clouds methought would open and show riches
Ready to drop upon me; that, when, I wak'd,
I cried to dream again.

Shakespeare, *The Tempest*

(Act III, scene II)

SMARRA OR THE DEMONS OF THE NIGHT

THE PROLOGUE

How sweet it is, my Lisidis, when the last chiming of the midnight bell dies away in Arona's towers — how sweet it is to share that bed, long solitary, where for a year I had but dreamed of you.

You are mine, Lisidis, and the evil genies whose tricks once prevented your Lorenzo from witnessing your graceful sleep, hold sway no more!

Rightly was it said, you may be sure, that those nocturnal terrors which assailed my soul during the hours intended for repose, were but a natural result of my assiduous study of the marvellous poetry of the ancients, and of the impression made upon me by certain fantastical fables of Apuleius, for his first book holds the imagination in a grip so fierce and painful that I could not wish, at the price of my eyes, that ever it should fall beneath your own.

Let no one speak to me of Apuleius and his visions any more; nor of the Latins nor the Greeks, nor of the bedazzling whimsies of their genius. Are you not, for me, a poetry lovelier than poetry itself, my Lisidis, richer in sweet enchantments than all nature?

But you sleep, child, and no longer hear me. At Isola Bella this night you danced too long at the ball. You danced too long, especially when you were not dancing with me, and now you are as weary as a rose shaken all night by the breeze, and which awaits the first light of morning on its half-bent stem to rise again, more blushing than before.

Then sleep beside me, your forehead against my

arm, warming my breast with the scented softness of your breath. Sleep is stealing over me, too, but this time it falls upon my eyelids almost with the grace of one of your kisses. Sleep, Lisidis, sleep.

..............................

There is a moment when the spirit, suspended in the emptiness of thought... Peace! Now night has covered the earth, no longer do you hear the footsteps of the returning townsman ringing on the cobbles or the clattering mules returning to their stalls. All you hear now is the wide soughing through the ill-fitting casement boards, and soon you feel that even this is but in your imagination. It becomes the voice of your soul, the echo of an idea, indefinable but fixed, which mingles with the first sensations of sleep. You are embarking upon that nocturnal life which unfolds (O miracle!) in worlds for ever new, amongst innumerable creatures whose forms the great Spirit has conceived but not deigned to create, and which he has merely scattered, mysterious and inconstant phantoms, throughout the boundless world of dreams. Bemused at evening's stir, Sylphs descend around you, humming. Their moth-wings beat against your drowsy eyes and you see the motley pollen they give off floating in the darkness like a little cloud of light in the midst of a fading sky. They throng, they embrace and mingle, eager to resume the magic converse of former nights, and to tell each other of unheard of events which nonetheless present themselves to your spirit in the form of a marvellous remi-

19

niscence. Gradually their voices die down, or reach you only through an unknown medium which transforms their tales into living pictures, and makes you an involuntary actor in the scenes they have prepared; for the imagination of the sleeper, in thrall to his independent and solitary soul, partakes in some sort of the perfection of the spirits. It soars with them and, borne miraculously aloft in the midst of the aerial choir of dreams, it flies from wonder to wonder until the moment when the song of a dawn bird alerts its venturesome escort to the return of light. Startled by the premonitory call, the sylphs gather like a swarm of bees at the first rumble of thunder, when great drops of rain bow the crowns of the swallow-skimmed flowers; they intermingle like atoms drawn by contrary forces, and vanish pell-mell into a ray of sunlight.

SMARRA OR THE DEMONS OF THE NIGHT

THE STORY

... O rebus meis
Non infideles arbitrae,
Nox, et Diana, quae silentium, regis,
Arcana cum fiunt sacra;
Nunc, nunc adeste...

<div style="text-align: right">

Horace, *Epodes, V.*

</div>

(O faithful witnesses
of my works,
Night, and you, Diana,
who surrounds our sacred mysteries
with silence,
come now, come...)

I had just finished my studies at the school of philosophy in Athens and, curious to see the beauties of Greece, I was visiting Thessaly, praised in poetry. My slaves were awaiting me at Larissa in a palace made ready to receive me. The forest of Thessaly, with its long curtains of green trees that run along the banks of the Peneus, is famous for the deeds of its sorceresses, and I had wanted to traverse it alone, during the grandeur of the night. The deep shade that lay beneath the immense canopy of the woods barely allowed the tremulous ray of some pale, misty star to struggle through its branches, in a clearing perhaps opened by the woodman's axe. Despite myself my heavy eyelids were drooping over eyes weary of seeking out the

glimmering trace of the path as it vanished into the undergrowth, and I could no longer resist sleep except by concentrating upon the noise of my horse's hooves as they whistled in the sand or sighed through the dry grass. If he stopped occasionally I, awakened by his stillness, would call out his name loudly, hastening his step, which had slowed in sympathy with my own weariness (but which was yet too slow for my impatience). Alarmed by some unknown obstacle, he would bound forward, neighing nervously, nostrils flaring, or rear up in terror, backing in even greater alarm at the sparks which the broken pebbles set flying against his feet...

'Phlegon, Phlegon,' I would say to him, my weary head falling upon his neck, which bristled in fright, 'O my dear Phlegon! We are nearly at Larissa, where pleasure, and above all sweet sleep, await us! One more moment's courage, and you shall bed down upon choice flowers; for the golden straw gathered for the oxen of Ceres is not cool enough for you!' 'Do you not see...' said he, quivering...' the torches they are brandishing before us are shrivelling the heather and mingling mortal vapours to the air I breathe... How can I breach their magic circles and their menacing dances, which would affright the very horses of the sun?'

But my horse's steady tread continued ringing in my ears, and the deepest sleep held my disquiet at bay. Yet from time to time a group lit by weird flames passed laughing over my head... or a deformed spirit, in the form of a beggar or a wounded man, would cling to my foot and allow itself to be dragged after me with an

awful glee; or some hideous old man, in whom the shameful ugliness of crime was wedded to that of age, would leap on to my horse's rump behind me and hold me in his arms, fleshless as those of death itself.

'Come, Phlegon,' I would exclaim, 'come now, finest of the steeds nurtured on mount Ida, brave now these baneful terrors which are hobbling your courage! These demons are but vain appearances. My sword, swung in a circle around your head, cleaves their deceiving forms, which dissipate like clouds. When the mists of morning float above our mountain peaks and, struck by the morning sun, throw round them a half-transparent girdle, the summits, separated from their base, appear suspended in the skies as though by an invisible hand. It is thus, Phlegon, that the sorceresses of Thessaly are cloven by the keen edge of my sword. Do you not hear the distant shouts of joy rising from the walls of Larissa?... Behold the towers of the pleasure-loving city of Thessaly; that air-borne music is the song of her young girls!'

O you seductive dreams, cradles of the soul drunk on the ineffable memories of pleasure, which amongst you will restore to me the song of the young girls of Thessaly, the langorous nights of Larissa?... Amidst translucent marble columns, beneath twelve shining domes whose gold and crystal reflect the sparkle of a hundred thousand torches, the young girls of Thessaly, clad in the coloured vapours that all scents exhale, are no more than vague, captivating outlines on the point of vanishment. A wondrous cloud wavers about them or casts the shifting play of its light upon

their lively groups: the fresh hues of the rose, the changeful light of dawn, the dazzling chinking of the rays of the capricious opal; a rain of pearls tumbles over their light tunics, sometimes aigrettes of fire start from every knot of the golden bands which hold their hair. Do not be alarmed if they look paler than the other maidens of Greece. They are scarcely of this earth, and seem to be shaking off the sleep of a past life. They are sad, too, either because they come from a world where they have left the love of a spirit or a God, or because an immense need to suffer lies in the heart of every woman in whom love is dawning.

But listen. Those are the songs of the young girls of Thessaly — that music rising in the air like a graceful cloud stirs the lonely leaded windows of those ruins dear to poets. Listen! The girls bend over their ivory lyres, question the ringing strings which answer once, vibrate for a moment and, falling still again, prolong an endless harmony heard by the spirit with all its senses: a melody as pure as the sweetest thought of a joyous soul, as the first kiss of love before love knows itself; as the gaze of a mother rocking the cradle of a child whose death she has just imagined, and which has just been brought into her presence, calm and lovely in its sleep. Thus the last sigh of the sistrum of a young woman, disappointed by her lover, is abandoned to the airs, fading in echoes, suspended amidst the silence of the lake, or dying with the wave at the foot of the unfeeling rock. The girls look at one another, lean towards each other, console each other, link their elegant arms, mingle their flowing hair, dance to spite the nymphs, their feet

sending up clouds of burning dust which swirls, glimmers, pales and falls to earth again in silvery ashes; and the harmony of their song flows on like honey, like some graceful stream whose murmurs bring gaiety to its winding, sunlit banks, with their cool shadowy curvings, butterflies and flowers. They sing...

One alone perhaps... tall, motionless and standing thoughtfully... O Gods! How sombre and mournful she looks, lagging behind her companions, and what does she want of me? Ah! Do not pursue my thoughts, flawed simulacrum of the beloved who is no more, do not trouble the peace of my evenings with your reproachfulness. Leave me, for I have wept for you for seven years; though it still sears my cheeks, let me forget my weeping, in the innocent delights of dancing sylphs and faery music. Look, here they are, you can see their groups forming, swelling to make human garlands, yielding, standing firm, breaking off, replacing one another, now drawing close, now drawing back, rising like the wave carried by the flow, then sinking, and bearing on their fleeting swell all the colours of the scarf of Iris which embraces sea and sky at the end of the storm when, dying, it breaks the end of its great circle against the prow of a vessel.

What do I care for accidents at sea, or the strange unease of the traveller, I whom divine favour (which was perhaps one of the privileges of men in a former life) frees, when I wish it (delicious benison of sleep) from all the dangers which threaten you? Hardly have my eyes closed, hardly has the ravishing melody ceased, than the creator of the marvels of night hollows

some deep abyss before me, some unknown chasm where all forms, all sounds, all sights of the world die away; than he casts, across a seething, greedy torrent of dead souls, some hasty, narrow, slippery bridge, offering no possibility of escape; than he hurls me to the end of a quavering, tremulous plank overlooking precipices the eye itself fears to plumb... calmly, I strike the obedient ground with a foot accustomed to command. It yields, responds, and I depart; happy to leave humanity behind, I see the blue stream of the continents slipping away beneath my easy flight, the sombre deserts of the sea, the dappled roofs of the forests streaked by the young green of spring, the red and gold of autumn, the mat bronze and lustreless violet of the shrivelled leaves of winter. If I hear the whirring wings of some startled bird, I surge on upwards, rising higher still, aspiring to new worlds. The river is no more than a thread vanishing into sombre greenery, the mountains merely vague points whose peaks now sink into their base, the ocean but a dark stain upon a mass lost in the ether, where it spins faster than the six-sided knucklebone rolled on its pointed axis by the little children of Athens, down the broad-paved galleries which surround the Kerameikos.

Along its walls, when they are touched by the rays of the life-giving sun during the first days of the year, you may have seen a long file of haggard men, motionless, their cheeks gouged by need, their expressions glazed and vacuous: some crouching like brutes; others standing, but leaning against pillars, half-bowed beneath the weight of their own emaciated bodies. Have

you seen them, their mouths agape in their desire to breathe once more the first waft of revivifying air, to garner with bleak relish the sweet sense of the mild air of spring? The same sight would have struck you on the walls of Larissa, for there are unfortunates everywhere: but here misfortune has a particular ineluctability which is more degrading than poverty, sharper than hunger, more crushing than despair. These unfortunates creep forward slowly in their line, pausing at length beneath steps, like mechanical figures set up by some cunning magician on a wheel which registers the passing of time. Twelve hours go by while the silent cortège hugs the contours of the circus, in reality so small that from one side to the other a lover can decipher, upon his mistress's half-opened hand, the hour of the night which will usher in the longed-for moment of his rendez-vous. By now these living spectres have been stripped of almost every vestige of their humanity: their skin is like white parchment drawn tightly over their bones, their eyes are lifeless. Their drained lips quiver with alarm or, more hideous yet, are stretched into a grim and haughty smile, like the last stand of a condemned man, resolute upon the block. Most are shaken with slight but continual convulsions, and tremble like the prongs of a Jew's harp. The most pitiable of all, vanquished by hounding fate, are doomed for ever to alarm the passers-by with the repulsive deformity of their gnarled limbs and frozen attitudes. Yet this recurrent pause between two periods of sleep is for them a time of respite from the pains they fear the most. Victims of the vengeance of the sorceresses of

Thessaly, as soon as the sun, dipping below the horizon, ceases to protect them from those redoubtable mistresses of the shadows, they are condemned again to fall prey to torments which no language can express. That is why they follow his all too rapid course, their gaze ever fixed upon it, in the ever-disappointed hope that he will once forget his bed of azure, and remain suspended amidsts the golden clouds of evening. Scarcely has night arrived to undeceive them, unfurling her wings of crepe (wings drained even of the glimmer just now dying in the tree-tops); scarcely has the last glint still dancing on the burnished metal heights of the tall towers ceased to fade, like a still glowing coal in a spent brasier, which whitens gradually beneath the ashes, and soon is indistinguishable from the rest of the abandoned hearth, than a fearful murmur rises amongst them, their teeth chatter with despair and rage, they hasten and scatter in their dread, finding witches everywhere, and ghosts. It is night... and hell will gape once more.

There was one, in particular, whose joints jangled like tired springs, and whose chest gave out a sound more raucous than that of a rusty bolt thrust painfully home. Yet some vestiges of rich embroidery, still hanging from his cloak, an expression full of grace and sadness which lit up the lassitude of his defeated features from time to time, some elusive mingling of debasement and pride which brought to mind the despair of a panther subjected to the hunter's cruel curb, caused him to stand out from the crowd of his wretched companions; when he passed before women, one heard but a sigh. His blond hair fell in untended curls upon

his shoulders, which rose white and pure as lilies above his purple tunic. Yet his neck bore the mark of blood, the triangular scar of an iron lance, the mark of the wound which had wrenched Polemon from me at the siege of Corinth, when that faithful friend threw himself upon my breast in the face of the unbridled rage of a soldier, already victorious but eager to yield up one more corpse to the battle field. It was that Polemon whom I had mourned for so long, who always returns to me in my sleep to remind me, with a cold kiss, that we shall meet again in death's immortal realm. It was Polemon, still alive, but preserved for an existence so horrible that the ghosts and spectres of hell consoled one another by recounting his sufferings; Polemon having fallen under the sway of the sorceresses of Thessaly and of the demons who make up their train during the inscrutable rites of their nocturnal celebrations. He stopped, astonished, sought to link some memory to my features, approached me with cautious, measured steps, touched my hands with his own, which trembled with eagerness as he did so; after having enveloped me in a sudden embrace, which I experienced not without alarm; after having fixed a veiled gaze upon me, as pale as the last glimmer of a torch being drawn away from the grilles of a dungeon: 'Lucius! Lucius,' he cried out with a frightful laugh.

'Polemon, my dear Polemon, Lucius' friend and saviour!...'

'In another world,' he said, lowering his voice; 'I remember... was it not in another world, in a life which was not in thrall to sleep and its phantoms?...'

29

'What phantoms are these of which you talk?...'

'Look,' he answered, pointing in the twilight. 'Behold them there.'

O unfortunate young man, do not succumb to fear of shadows! When the shade of the mountains creeps down, spreading like ink, so that the tips and sides of the gigantic cones grow closer and at least embrace each other in silence on the darkling earth; when the eerie images of the clouds spread, mingle and withdraw beneath the protective veil of night, like clandestine couples; when the birds of ill-omen begin to call from beyond the woods, and the hoarse voice of reptiles croak tonelessly at the marsh's edge... then, my Polemon, do not deliver your tormented imagination over to the illusions of shadow, and solitude. Flee the hidden paths where spectres meet to brew black spells to trouble men's repose; flee the purlieus of cemeteries, where the dark councils of the dead foregather, wrapped in their shrouds, to appear before the Areopagus, seated on biers; flee the open meadow where the trampled grass blackens, and becomes dry and sterile beneath the witches' steady tread. Trust my word, Polemon: when the light, alarmed at the evil spirits' approach, sinks and turns pale, you should come with me to rekindle its marvels in opulent festivities, in sensual dalliance. Have I ever lacked for gold? Have the richest mines so much as one hidden vein which keeps its treasures from me? Under my hand the very sand of the streamlets is transformed into exquisite stones which would be fitting ornament for the crowns of kings. Do you trust my word, Polemon? Daylight would fade in

vain, as long as the fires lit by its rays for the delight of man still leap to illumine his feasts or, more discretely, to set aglow the sweet vigils of love. The Demons, as you know, fear the odorous vapours of wax and scented oil which shine softly in alabaster, or pour rose-coloured shadows through the double silk of our rich hangings. They shudder at the sight of polished marble, lit by chandeliers, casting around them trails of diamonds, like waterfalls struck by the first farewell glance of the retiring sun. Never did sombre lamia or fleshless spectre dare to display its hideous ugliness at the banquets of Thessaly. The very moon on which they call, often alarms them, when it casts upon them one of those roving beams which give a deathly pewter pallor to the object upon which it falls. At such moments they run off faster than the snake warned by the slithering of the sand stirring beneath the traveller's foot. Do not fear that they may surprise you in the midst of the lights that sparkle in my palace, reflected from all sides in the mirrors' dazzling steel. See rather, my Polemon, with what eagerness they take their distance from us when we progress between the servants' torches along these galleries of mine, decorated with statues — the matchless masterpieces of the genius of Greece. Has any threatening movement on the part of one of these images ever revealed to you the presence of those uncanny spirits which sometimes animate them, when the last glimmer from the last lamp fades in the air? Their motionless forms, the purity of their features, the serenity of their attitudes, would reassure fear itself. If some strange noise has struck your ear, beloved brother

of my heart, it is that of the watchful nymph who spreads the treasures of her crystal urn over your sleep-numbed limbs, mingling scents hitherto unknown to Larissa: an amber liquid which I gathered on the shores of seas which bathe the cradle of the sun: the sap of flowers a thousand times sweeter than the rose, which grow only in the deep shade of brown Corcyra; the tears of a shrub beloved of Apollo and his son, and which spreads its bouquets over the rocks of Epidaurus, deep-red cymbals trembling beneath the weight of the dew. And how could the spells of the sorceresses trouble the purity of the waters which rock their silver waves around you? And then the lovely Myrthé, with her flaxen hair, the youngest and best-beloved of my slaves, the one whom you saw bow down as you passed, for she loves all that I love... she has spells known only to her and to the spirit who entrusted them to her in the mysteries of sleep; now she wanders like a shade through the enclosures of the baths where the surface of the health-giving water gradually rises; she runs to and fro, singing airs which ward off the demons, sometimes touching the strings of a wandering harp which obedient genies offer her even before her desires can be made known by passing from her soul into her eyes. She walks; she runs; and the harp sings beneath her hand. Listen to the echoing voice of Myrthé's harp; it is a full, grave, lingering sound, which banishes all earth-bound thoughts, filling the soul like a leitmotiv; then it takes wing, flees, vanishes and returns; ravishing enchanters of the night, the airs of Myrthé's harp soar and fade, return again — how it

sings, how they fly, the airs of Myrthé's harp which ward off demons!... Listen, Polemon, do you hear them?

In truth I have experienced all the illusions of dreams, and what would I have become without the succour of Myrthé's harp, without its voice, so sweetly disturbing the pained groaning that passed for sleep?... How many times have I bent in my slumber over the limpid, sleeping wave, only too faithful in reproducing my ravaged features, my hair on end with terror, my gaze as fixed and lustreless as the look of despair when it can no longer weep!... How often have I shuddered, seeing traces of livid blood around my pallid lips; feeling my loosened teeth driven from their sockets, my nails, torn from their roots, prized free! How many times, alarmed at my shameful nudity, or wearing a tunic shorter, lighter, more transparent than that worn by a courtesan as she enters the brazen bed of debauchery, have I not given myself over nervously to the jeers of the crowd! O, how often dreams more hideous yet, dreams Polemon himself is unacquainted with... what then would I have become without the succour of Myrthé's harp, without her voice and the harmony she imparts to her sisters, when they cluster obediently around her, to dispel the terrors of the wretched sleeper, to fill his ears with songs from far away, like breezes whispering into flying snails — songs which commingle and conspire to still the heart's storm-tossed, tormented visions and to becalm them with long melody.

And now, behold the sisters of Myrthé, who have prepared the feast. There is Theis, unique among the daughters of Thessaly: most girls of that land have

black hair falling upon alabaster shoulders; none has the supple, sensuous curls of black-haired Theis. It is she who holds a delicate earthen vessel where the wine simmers palely, letting fall from it, drop by drop like liquid topaz, the most exquisite honey ever gathered on the young elms of Sicily. Despoiled of her treasures, the bee flies restlessly amidst the flowers; she hangs from the lonely branches of the abandoned tree, claiming her honey from the zephyrs. She murmurs in pain, for her little ones will no longer have a haven in any of the thousand five-walled palaces she built for them of a light, translucent wax, nor will they taste the honey she has gathered for them on the scented bushes of mount Hybla. It is Theis who pours the honey stolen from the bees of Sicily into the simmering wine; and her other sisters, those who have black hair — for only Myrthé is fair — run in smiling and obedient haste to make the banquet ready. They scatter pomegranate flowers or roseleaves on the foaming milk; or fan the fires of amber and incense burning beneath the cup where the hot wine seethes; the flames bow respectfully along the vessel's rounded brim, and draw nigh, caressing its golden outlines to merge at last with the gold and blue-tongued flames which dance above the wine. The flames rise and fall, flickering like the lonely will-o'-the-wisp which loves to gaze upon itself in fountains. Who can say how many times the cup has passed around the festive table, how often, drained, its lip has been flooded with fresh nectar? Maidens, spare neither wine nor hydromel. The sun forever swells new grapes, forever pours the rays of its immortal splendour on the

bursting clusters which sway on the rich swags of our vines, glimpsed through the darkling vine-shoots wreathed in garlands which run between the mulberry trees of Tempe. One more libation to drive off the demons of the night! I myself now see only the joyous spirits of drunkenness bubbling forth from the foam, chasing one another through the air like fire-flies, or dazzling my hot eyelids with their radiant wings; like those fleet insects which nature has bedecked with harmless fires, and which burst in swarms from a tuft of greenery in the quiet cool of brief midsummer nights, like a sheaf of sparks beneath the blacksmith's hammer. They float, wafted on a slight passing breeze, or summoned by some sweet scent on which they feed in the rose's chalice. The light-filled cloud hangs, ever-changing, rests or turns fleetingly upon itself, and sinks in its entirety to cloak the summit of a young pine tree, which it illumines like the time-honoured pyramid at a village fete; or shrouds the lower branches of a great oak tree, made to seem a girandole for some forest gathering. See how they play around you, how they spin through the flowers, how they glow in fiery strands against the polished vessels; these are no enemy demons. They dance, they are glad, with all the abandon and insouciance of madness. If they sometimes trouble the repose of men, it is merely to satisfy some laughing whim, like a heedless child. Mischievously they become entwined in the tangled flax on the spindle of an old shepherdess, muddling the threads, while knots proliferate beneath her fingers' futile skill. When a lost traveller scans the night horizon for some source of light that might offer

him shelter, they send him wandering from path to path, by the light of their fickle glow, to the sound of a deceiving voice, or of the distant barking of a watchful dog, prowling like a sentinel around a solitary farm; thus they abuse the hopes of the poor wanderer, until the moment when, touched with pity at his weariness, they suddenly present him with an unexpected resting-place, hitherto unremarked in all this wilderness; sometimes indeed, on his arrival, he is astonished to find a crackling hearth whose very sight inspirits, and rare and delicate dishes brought by pure chance to the cottage of the fisherman or poacher, and a young girl, as lovely as the Graces, to serve him, too modest even to raise her eyes; for she feels that this stranger is dangerous to look upon. The next day, surprised that so brief a respite has so thoroughly revived him, he arises cheerfully to the song of the lark greeting a pure sky; he learns that his fortunate error has shortened his route by twenty leagues, and his horse, whinnying with impatience, nostrils flaring, coat lustrous, mane smooth and shining, is pawing the ground before him in a triple indication of departure. The imp bounds from the rump to the head of the traveller's horse, runs his cunning hands through the vast mane; looking about him, he is pleased with what he's done, and departs gleefully to amuse himself at the plight of a parched sleeper who sees a cooling draft receding, then drying up before his proffered lips; he plumbs the vessel pointlessly with his gaze, and vainly sups up the absent liquid; he then awakens, and finds the cup filled with a Syracusan wine he has never tasted, which the elf has extracted from the

choicest grapes, making sport of the frettings of his sleep. Here you can drink, speak and sleep without fear, for the elves are our friends. Only you must satisfy the eager curiosity of Theis and Myrthé, and the less impartial curiosity of Thelaire, who has fixed you with her great dark eyes, with their long lustrous lashes — eyes like auspicious stars in a sky awash with the most tender azure. Tell us, Polemon, of the outlandish sufferings you were experiencing under the sway of the sorceresses: for the torments with which they dog our imagination are but the vain illusions of a dream which fades at the first light of dawn. Theis, Thelaire and Myrthé are attentive... They are listening... speak, then, tell us of your despair, your fears, all the mad fancies of the night; Theis, pour us some wine; Thelaire, smile at his tale, so that his soul is comforted; and you, Myrthé, should you see him yield to a new illusion, surprised at the memory of his aberrations,... must sing to him and pluck the strings of your beguiling harp... Draw heartening sounds from it, sounds which dispel bad spirits... thus one may deliver the bleak hours of the night from the tumultuous power of dreams, and thus escape, moving from pleasure unto pleasure, from the sinister wizardry which fills the world during the absence of the sun.

SMARRA OR THE DEMONS OF THE NIGHT

THE EPISODE

Hanc ego de coelo ducentem sidera vidi;
Fluminis haec rapidi carmine vertit iter.
Haec cantu finditque solum, manesque sepulchris
Elicit, et tepido devorat ossa rogo.
Quum libet, haec tristi depellit nubila coelo:
Quum libet, aestivo convocat orbe nives.

<div align="right">Tibullus</div>

('I myself have seen this woman draw the stars from the
sky; she diverts the course of a fast-flowing river with
her incantations; her voice makes the earth gape, it lures
the spirits from the tombs, sends the bones tumbling
from the dying pyre. At her behest, the sad clouds
scatter; at her behest, snow falls from a summer's sky'.

<div align="right">Catullus, Elegies, 1, 2.)</div>

[Attributed by Nodier to Tibullus but actually by
Catullus.]

For this, be sure, to-night thou shall have cramps,
Side-stitches that shall pen thy breath up; urchins
Shall forth at vast of night, that they may work
All exercise on thee; thou shalt be pinch'd
As thick as honeycomb, each pinch more stinging
Than bees that made them

<div align="right">(Tempest Act I scene II)</div>

SMARRA OR THE DEMONS OF THE NIGHT

Who amongst you, O young maidens, is unacquainted with the sweet caprices of women, asked Polemon in delight. You have probably known the power of love, and how the heart of a pensive widow, led by her solitary memories to pace the sandy banks of the Peneus, sometimes allows herself to be surprised by some dark-skinned soldier whose eyes are sparkling with the fire of war, and whose breast shines with the éclat of a glorious scar. Tender and proud, he walks amidst women like a tame lion trying to drown his memories in the pleasures of an easy servitude. Thus does the soldier love to occupy a woman's heart, when the clarion call of battle no longer summons him, when the hazards of combat no longer claim his vaulting ambition. He smiles under the glances of young girls, and seems to say to them: Love me!...

Since you are women of Thessaly, you know too that no woman's beauty ever equalled that of the noble Méroé: since her widowhood, she has been trailing long white draperies, embroidered with silver: Méroé, the most beautiful of the beauties of Thessaly. She is as majestic as a goddess, yet there is some mortal fire in her eyes which emboldens thoughts of love. O how often have I breathed in the air that moves around her, trodden the dust her feet set flying, relished the happy shade which follows her!... How often have I thrown myself before her steps to steal a glance, a breath, an atom from the whirlwind which surrounds her every movement; how often (Thelaire, will you forgive me?) have I seized the delicious opportunity of feeling the merest fold of her garment moving against my tunic, or

holding to eager lips one of the sequins which fell from her embroidered robes in the walks of the gardens of Larissa! When she passed by, you see, the clouds would blush as at the approach of a storm; my ears would hum, my eyes would darken in their staring sockets, my heart was overwhelmed beneath the weight of an intolerable joy. She was there! I would salute the shadows which had flowed over her, I would breath the air which had surrounded her; I asked the trees on the river edge if they had seen my Méroé; if she had been stretched out on some flowery bank, with what jealous love I plucked the flowers which her body had bowed — the carmine-streaked petals fringing the bent head of the anemone, the dazzling arrows which burst from the golden disk of the ox-eye daisy, the chaste gauze veil which winds around a young lily before it has opened to the sun; and if I dared throw myself upon this bed of cool verdure in a sacrilegious embrace, it was because she fired me with an ardour keener than that with which death weaves the night-time garments of a fevered man. Méroé could not have failed to notice me. I was everywhere. One day, at the approach of twilight, I caught her gaze: it proffered hope; she had been walking before me, and I saw her turn. The air was calm, her hair unruffled, yet she raised her hand as though to make good its disarray. Lucius, I followed her as far as the palace, the temple of the princesses of Thessaly, and night surprised us, a night of joys and terrors!... O that it might have been my last.

I do not know if you have ever borne on your outstretched arm the weight of the body of a sleeping

mistress who has abandoned herself to repose, unaware of your torments (a burden borne with resignation tinged with impatience, and with tenderness); if you have tried to struggle against the *frisson* which rises gradually in your blood, against the numbness which enchains your subject muscles; to parry death, which now threatens to engulf your very soul. It is thus, Lucius, that a painful tremor ran rapidly throughout my sinews, setting them unexpectedly aquiver, like the sharp spikes of the *plectrum* which makes all the strings of the lyre cry out in discord under the fingers of a skilled musician. My flesh seethed like a dry membrane brought near to the fire. My heaving breast was nigh to bursting the iron bonds which enveloped it, when Méroé, suddenly seated at my side, fixed me with a piercing look, stretched out her hand upon my heart to ascertain that its movement was suspended, leaving it to rest there, heavy and cold, and then fled from me with the speed of an arrow which the archer's string lets fly with a whirring sound. She sped across the marble floor, reciting the songs of the shepherdesses of Syracuse which beguile the moon in its nacreous silvery clouds, paced through the depths of the vast hall, crying out from time to time in bursts of chilling gaiety, to shadowy friends as yet unknown to me.

While I watched, full of terror, and saw a countless throng of vapours, distinct from one another, yet mere substanceless forms, passing along the walls, hastening beneath the porticoes, swaying under the vaulting; uttering sounds as faint as that of the stillest pool on a silent night, with a shifting of colour bor-

rowed from the objects behind their floating, transparent forms...suddenly a blue-tinged flickering flame burst forth from the tripods, and Méroé, mistress of the scene, flew from one to another murmuring confusedly: 'Here be flowering verbena... there, three sprigs of sage gathered at midnight in the cemetery of those who perished by the sword... here, the veil of the beloved beneath which her lover hid his pallor and his desolation after having slit the throat of her sleeping husband in order to enjoy her favours... and here, the tears of a tigress overcome by hunger, inconsolable at having devoured one of her little ones!'

Her shattered features expressed such suffering and horror that I almost felt pity for her. Alarmed at seeing her spells thwarted by some unforeseen obstacle, she leapt with rage and disappeared, to return armed with two long wands, linked at their extremities by a flexible tie composed of thirteen hairs plucked from the neck of a superb white mare by the very thief who had killed his master; on this she set bounding the ebony *rhombus*, with its empty, sonorous globes: wildly it hummed and whirred in the air, then, with a muffled sound, slowed down and fell. The flames of the tripods strained like serpents' tongues, the shades were satisfied. 'Come, come,' cried Méroé, 'the demons of the night must be appeased, the dead must rejoice. Bring me flowering verbena, sage picked at midnight, four-leaved clovers; bring an abundance of pretty bouquets to Saga and the demons of the night.' Then she cast a distracted eye upon the gold asp, whose coils were encircling her naked arm; upon her precious bracelet,

the work of the most skilled artist of Thessaly, who had skimped on neither choice of metals nor on the perfection of the craftsmanship, encrusted as it was with delicate scales of silver, nor was there one whose pallor was not heightened by the glow of a ruby or the lovely transparency of a sapphire bluer than the sky. She removes it, she ponders, she dreams, she summons the serpent, murmuring secret words; and the serpent, coming to life, uncoils and snakes off with a hiss of joy like a freed slave. And the *rhombus* turns again; it turns, rumbling, like receding thunder groaning in clouds borne off by the wind, in an abating storm.

Meanwhile, the vault opens up, the expanses of the sky are revealed, the stars come down, the clouds sink lower and bathe the threshold in a court of shadow. The moon, spattered with blood, resembles the breast-plate upon which the body of a young Spartan, his throat slit by the enemy, has just been brought in. I feel its livid disk weighing upon me, clouded yet further by the smoke from the extinguished tripods, Méroé continues her headlong course, striking the countless columns of the palace, from which long trails of light leap forth; each column divides under Méroé's fingers to reveal an immense colonnade peopled with phantoms, and each phantom strikes, as she does, a column which reveals new colonnades; nor is there any column which is not witness to the sacrifice of a new-born babe snatched from its mother's cradling arms. Pity! I cried, pity for the hapless mother who, for her child, would challenge death itself. But this stifled prayer reached my lips with no more strength than the

43

breath of a dying man saying: Adieu! It died away in purlings on my stammering mouth. It faded like the call of a drowning man, in vain committing his last, desperate cry to the voiceless waters. The unresponsive element muffles his voice; it sheathes him, grim and cold; it devours his plaining; never will it reach the shore.

While I was struggling against the terror which had seized me, and trying to pluck from my breast some curse that might arouse the vengeance of the gods in heaven: O wretched one, cried Méroé, may you be punished for ever for your insolent curiosity! Ah! You dare to violate the enchantments of sleep... You speak, you cry out and you see... Well! You shall speak no more but to lament, you shall cry out no more but to implore the hollow pity of the absent, you shall see no more but scenes of horror which will chill your soul!' Thus expressing herself, in a voice more searing and high-pitched than that of a wounded hyena still threatening its hunters, she took from her finger the iridescent turquoise which sparkled with lights as varied as the colours of the rainbow, or as the wave which rears up with the rising tide, reflecting, as it furls upon itself, the mingled hues of the rising sun. She presses the hidden spring, to reveal a golden casket containing a colourless and formless monster, which thrashes and howls and leaps and falls back crouching on the enchantress' breast. 'There you are, my dear Smarra,' she says, 'sole darling of my amorous thoughts, you whom the hatred of the heavens has chosen amongst all their treasures to wreak despair among the sons of men. I order you to go

44

now, fond, beguiling or terrible spectre, go and torment
the victim I have delivered up to you; plague him with
tortures as cruel and implacable as my own wrath. Go
and sate yourself upon the anguish of his beating heart,
count the convulsive poundings of his quickening pulse
at it speeds up or grows slow... contemplate his painful
death throes and suspend them merely in order to begin
again... This is the price, oh faithful slave of love, to be
extracted at the gate of dreams before you sink once
more upon the scented pillow of your mistress, and
embrace the queen of nightly terrors in your loving
arms...'. She speaks, and the monster leaps from her
burning hand like the rounded quoit of the discobolus;
he spins in the air with the speed of those fireworks
they launch on ships, spreading his weirdly scalloped
wings, rises, falls, swells, diminishes and, like some
deformed and gleeful dwarf, his fingers armed with
nails of a metal finer than steel, which penetrate the
flesh without rending it, and suck the blood from it like
the insidiously pumping leech, he clamps himself upon
my heart, swells, lifts his great head and laughs. In vain
my gaze, frozen with fear, spans the space it can
encompass for the sight of some consoling object: the
thousand demons of the night escort the fearful demon
of the turquoise. Stunted, wild-eyed women; purple-red
snakes whose mouths spit flame; lizards poking human
faces above the lake of mud and blood; heads newly-
severed from their trunks by the soldier's war-axe, but
which look at me with living eyes, hopping on reptiles'
feet...

Since that baneful night, O Lucius, there are no

more untroubled nights for me. The scented couches of young girls, which harbour but voluptuous dreams; the fickle tent of the traveller, put up each evening under new shade; the very sanctuaries of the temples are havens powerless against the demons of the night. Barely have my poor eyelids closed, weary of battling against abhorrèd sleep, than all the monsters are there, as at the moment I saw them bursting, with Smarra, from Méroé's magic ring. They run a circle round me, deafen me with their cries, affright me with their pleasures and sully my quivering lips with their harpy caresses. Méroé leads them and hovers above them, shaking her long hair, which gives off sparks of livid blue. Even yesterday... she was vaster than I had seen her before... her forms and features were the same, but beneath their seductive appearance I discerned, to my alarm, as though through some light gauze, the leaden hue of the sorceress and her sulphur-coloured limbs; her eyes, staring and hollow, were brimming with blood, tears of blood furrowed her gaunt cheeks, and her hand, moving through space, left printed on the very air the trace of a bloody hand... Come, she said to me, almost brushing me with a finger which would have destroyed me had it touched me, come and visit the empire that I give my husband, for I want you to know every domain of terror and despair... — And thus speaking, she flew before me, her feet barely off the ground, darting and swooping over the earth, like the flame that dances above a dying torch. How repugnant to all senses was the path we were speeding along. How impatient the sorceress herself appeared to reach its

46

end. Imagine to yourself the ghostly charnel-house in whose confines they pile the remains of all the innocent victims of their sacrifices; among even the most butchered of their mutilated remains, there is not a shred which has not retained a voice to groan and weep! Imagine shifting, living masonry, pressing upon your step from either side, gradually nudging your limbs like the confines of a chill and cramping prison... Your troubled breast strains to breath in something of the air of life amidst the dust of the ruins, the smoke of the torches, the damp of the catacombs, the poisonous exhalations of the dead... and all the demons of the night, wailing, hissing, howling or jibbering in your appallèd ear: You shall breathe no more!

As I walked, an insect a thousand times smaller than that which attacks the delicate tissue of the leaves of the rose with its paltry tooth, a deformed atom which takes a thousand years to move one step on the universal sphere of the heavens whose matter is a thousand times harder than the diamond... it too was walking; and the stubborn trace of its lazy feet had riven this imperishable globe down to its very axis.

After having thus crossed a distance for which the language of man has no term of comparison, so rapid was our course, I saw streaks of pale brightness burst from a barred opening as near as the remotest star. Full of hope, Méroé surged forward, I followed her, dragged by an unseen power; indeed the way back, blotted out like nothingness, infinite as eternity, had just closed in behind me in a way impenetrable to man's ingenuity and patience. Between Larissa and ourselves

there already yawned all the debris of the countless worlds which preceded our own in creation since the dawn of time, and most of which exceed it in immensity as the prodigious size of our own world exceeds that of the invisible nest of the gnat. The sepulchral gate which received us, nay sucked us in, as we left this abyss, opened on to a boundless, barren expanse. In one remote corner of the heavens one could just make out the vague outline of a steadfast, obscure star, stiller than the air, darker than the shadows which reign in this realm of desolation. This was the corpse of the oldest of suns, couched on the cloudy limits of the firmament, like a submerged boat sunk on a lake swollen by the melting of the snows. But the pale glimmer which now met my gaze did not come from this relic. It seemed to have no source and was just an especial hue of the night, or perhaps the result of the burning up of some remote world whose ashes were still smouldering. Then — it seemed barely possible — all the sorceresses of Thessaly appeared, escorted by the dwarves of the earth who labour in their mines, with their coppery faces and hair as blue as silver when it is in the furnace; by the long-limbed salamanders, with their oar-like tails and untold colours, which dart unharmed into the flames, like black lizards, through a fiery dusk; by frail-bodied Aspioles, with their deformed yet laughing heads, teetering on the bones of their fragile, hollow legs, like barren haulm strewn by the wind; by Achrones, which have neither limbs, nor voice, nor face, nor age, and who leap, weeping, over the moaning earth like goat-skins swollen with air; by the Psylles, snake-charmers

who dance in circles, avid for ever more cruel poisons, and who utter sharp hisses to awaken the serpents in their hidden lair, in their sinuous hiding-places; even by the Morphoses which you so loved, as beautiful as Psyche, which play like the Graces, give concerts like the muses, and whose seductive gaze, sharper and more venomous than the viper's tooth, will set your blood aflame and send the marrow seething in your calcined bones. You would have seen them, wrapped in their purple shrouds, trailing clouds brighter than the East, more scented than the perfumes of Arabia, lovelier than the first sigh of a virgin melted by love, their intoxicating vapour beguiling the soul merely in order to extinguish it. Sometimes their eyes send out a moist flame which entrances and devours; sometimes they bow their heads with a grace all their own, demanding your total trust with a caressing smile, the smile of a perfidious and living mask which conceals the delights of crime and the ugliness of death. What can I say? Drawn onwards by the whirlwind of spirits which floated like a cloud; like the blood-red smoke which settles above a burning city, like the liquid lava which spreads to form a network of innumerable molten, intertwining streamlets over an ash-strewn countryside... I arrived at last... All the tombs stood open... all the dead had been disinterred... all the ghouls were there — pale, impatient, hungry; they were straining at the planks of their coffins, rending their sacred garments, the final garments of the corpse; sharing hideous remains with an even more hideous relish and, with an iron hand — for I was, alas, as helpless a captive as a

49

babe in the cradle — they forced me — O terror — to partake with them of their execrable banquet!...'

As he finished these words, Polemon raised himself on his bed and, trembling, desperate, hair on end, his gaze fixed and awestruck, he called out to us in a voice that was not of this world. But the tunes of Myrthé's harp were already wafting across the air; the demons were quietened, the silence was as untroubled as the thoughts of the innocent man as he falls asleep on the eve of his judgement. Polemon was sleeping peacefully to the sweet sounds of Myrthé's harp.

SMARRA OR THE DEMONS OF THE NIGHT

EPODE

Ergo exercentur poenis, veterumque malorum
Supplicia expendunt; aliae panduntur inanes
Suspensae ad ventos, aliis sub gurgite vasto
Infestum eluitur scelus, aut exuritur igni.

(So here punishment awaits them, and they expiate their
former crimes most painfully: some, suspended in mid-
air, become the playthings of the winds; others, plunged
in a vast abyss, are washed clean of their crimes, or
purged in the fire.
Aeneid, VI, 739 — 742).

'Tis a custom with him
I' the afternoon to sleep: there thou may'st brain him,
Having first seiz'd his books; or with a log
Batter his skull, or paunch him with a stake,
Or cut his wezand with thy knife

(*Tempest* Act III, scene II)

51

The vapours of pleasure and wine had stunned my senses, and despite myself I saw the phantoms of Polemon's imagination pursuing one another into the darkest corners of the hall where the banquet had been held. Already he had fallen into a deep slumber on the flower-strewn bed, beside his overturned glass, and my young slaves, overtaken by a sweeter exhaustion, had let their heavy heads droop against the harp that they embraced. Myrthé's golden hair fell like a long veil over her face between the golden strings, which paled in comparison, and her sweet sleeping breath, falling upon them, continued to draw from them a voluptuous sound which faded as it reached my ears. Yet the phantoms were still there; they were still dancing in the shadows of the columns and in the haze of the torches. Impatient of this trick of drunkenness, I drew the cool branches of protective ivy down upon my head and firmly closed my eyes, tortured by the illusions of the light. Then I heard a strange noise, which seemed to be formed of voices alternately grave and threatening, insulting and ironic. One of them, with irritating monotony, was repeating several lines from a scene from Aeschylus; another, the last lessons addressed to me by my dying forebear; from time to time, like a breath of wind whistling through dead branches and withered leaves in lulls in a storm, a figure, whose breath I could feel, would burst into laughter against my cheek, and then withdraw, still laughing. Further bizarre and horrible illusions followed this one. I thought I saw all the objects which I had just looked upon as through a cloud of blood: they were floating before me, and pursuing

me, with horrible attributes and accusing groans. Polemon, still stretched out next to his empty cup, and Myrthé, still leaning upon her harp, were cursing me furiously and calling me to account for I know not what murder. As I was raising myself to answer them, and stretching out my arms over the couch, cooled by generous libations of liqueurs and perfumes, the joints of my quivering hands were seized by a cold sensation: it was like an iron noose, which at the same time fell upon my numbed feet, and I found myself pulled upright between two densely packed rows of ghostly soldiery, whose lances, tipped by dazzling spear-heads, resembled a long row of candelabras. Then I began to walk, seeking the carrier-pigeon's path through the sky, so that, before the arrival of the dread moment I was beginning to foresee, I might at least entrust to her sighs the secret of a hidden love which she might one day tell, hovering near the bay of Corcyra, above a pretty white house; but the pigeon was weeping on her nest, for the eagle had just snatched up the dearest of her brood, and I proceeded painfully and unsteadily towards the goal of my tragic course, amidst the murmur of awful glee which ran through the crowd, calling impatiently upon me to proceed — the murmur of a slack-jawed throng whose eyes were hungry for suffering, whose bloody curiosity would, from a distance, drink up all the victim's tears that the executioner would proffer them.

There he is, they all cried, there he is!

... 'I saw him on a battlefield', said an old soldier, 'and then he was not ghostly pale, but seemed

a brave warrior.'

'How small he is, this Lucius who was trumpeted as an Achilles or a Hercules!' continued a dwarf whom I had not previously noticed among their number. 'It is fear, probably, which is sapping his strength and causing his knees to buckle.'

— 'Could it ever have been that so much ferocity lodged in the heart of one man?' said a white-haired old man whose doubt froze my own. He resembled my father.

— 'Could this be he?' — said the voice of a woman, yet one whose physiognomy expressed such sweetness...' Could this be he?' she repeated, wrapping herself in her veil to avoid the full horror of my appearance...' could this be the murderer of Polemon and of the beautiful Myrthé?...'

'I think the monster is looking at me,' said one of the women. 'Close up, basilisk eye, viperous soul, may the heavens curse you!'

During that time the towers, the streets, the entire city was fleeing before me like a harbour abandoned by an adventurous vessel leaving to try the fortunes of the main. All that remained was a newly-built square, vast and regular, bordered with majestic buildings and filled with a flood of citizens of all stations, who were abandoning their posts in order to yield to the call of a particularly keen pleasure. The casements were teeming with eager onlookers, young people contending with their own brothers or mistresses for space in the narrow embrasures. The obelisk raised above the fountains, the carpenter's shuddering scaf-

folding, the mountebanks' trestles, all were thick with
spectators. Gasping with impatience and delight, men
hung from palace cornices, their knees grazing the tops
of the walls, chanting 'There he is!' with unrestrained
glee. A little girl in a crumpled blue tunic, whose wild
eyes signalled madness and whose fair hair was
spangled with sequins, was singing of my execution,
describing my death and the confession of my heinous
crimes, and her cruel lay informed my frightened soul
of criminal mysteries inconceivable to crime itself. I was
the centre of this whole spectacle, along with another
man, and several planks raised on posts, on which the
carpenter had fixed a rough seat and a block of roughly
squared wood about half a span above it. I climbed
fourteen steps; I sat down; I cast my gaze over the
crowd, seeking friendly features, some glimmer of hope
and of regret in the cautious gesture of a shame-faced
farewell; I saw only Myrthé: awakening, still holding (or
plucking) her harp, and laughing; only Polemon, who
was raising his empty cup and, still half stunned by the
vapours of drink, filling it again with an unsteady hand.
Calmer now, I delivered up my head to the sharp, chill
sabre of the officer of death. Never did a more penetrat-
ing shudder run down a man's spine; it was as startling
as the last kiss that fever lays upon the neck of a dying
man, as sharp as tempered steel, as engulfing as molten
lead. I was drawn from this anguish only by a terrible
commotion; my head had fallen... it had rolled, bounced
on to the hideous square in front of the scaffold and,
just as it was about to fall, ravaged, into the hands of
the children of Larissa, who sport with the heads of the

dead, it had caught upon a protruding plank, biting into it with the ungiving ferocity which rage lends to the jaw during the death throes. Thence I turned my eyes upon the assembly, which was withdrawing, silent but satisfied. A man had just died before the people. There was a final expression of admiration for the skill of the executioner, and a sense of revulsion for the murderer of Polemon and the beautiful Myrthé.'

'Myrthé, Myrthé!' I almost roared, though without leaving the plank which had proved my salvation.

'Lucius, Lucius!' she replied, half-asleep, 'will you never sleep quietly when you have had a glass too much? May the devils of hell forgive you; now cease troubling my rest. I would rather sleep to the sound of my father's hammer, in the smithy where he works his copper, than amidst the night-time terrors of your palace.'

While she was speaking to me, I bit stubbornly upon the wood, drenched with my freshly-spilled blood, and congratulated myself upon feeling the dark wings of death slowly unfurling beneath my mutilated neck. The bats of twilight skimmed around me caressingly, telling me to take wing... and I began beating some poor shreds of flesh which barely supported me. Yet of a sudden I felt a comforting illusion. Ten times I beat the sombre vault of heaven with the near-lifeless membrane I trailed behind me like the pliable feet of the reptile which coils in the sand in fountains; ten times I surged upwards, testing my skill gradually in the damp mist. How dark and chill it was! How melancholy were the

wastes of shadow. At last I rose to the top of the highest buildings, and hovered, circling around the solitary plinth, the plinth so recently touched by my dying mouth with a smile and farewell kiss. All the onlookers had disappeared, all noise had ceased; the stars were hidden, the lights extinguished. The air was still, the sky sea-green, dull and cold as matt sheet metal. Nothing remained of what I had seen and imagined on earth, and my soul, alarmed at being alive, fled a vaster solitude, a deeper darkness, than the solitude and darkness of nothingness itself. Yet I did not find the haven I was seeking. I soared upwards like the moth which had just broken free of its mysterious swaddling bands to display the unavailing luxury of its crimson, blue and gold finery. If, from a distance, it glimpses the casement of some scholar keeping a lonely vigil, writing by the light of a cheap lamp, or that of a wife whose young husband has stayed too long out hunting, it climbs the pane, tries to settle, beats fluttering wings against the glass, flies off, returns, hums and falls, shedding the transparent dust of its fragile wings. Thus did I beat the cheerless wings which death had lent me against the vaults of a brazen sky, which answered only with a dull echo, and I sank down once more, hovering in circles around the lonely plinth so recently touched by my dying mouth with a smile and a farewell kiss. The plinth was no longer empty. Another had just lain his head upon it, throat uppermost, and his neck revealed the trace of the wound, the triangular scar of the lancehead which had taken Polemon from me at the siege of Corinth. His golden curls lay twined all around

the bloody block: yet Polemon, serene, with eyelids lowered, seemed to be sleeping the sleep of the just. A smile, not yet the rictus of terror, played on his opened lips, and called forth new songs from Myrthé and further caresses from Thelaire. In the light of the pale morning which was beginning to spread through the precincts of my palace, I recognised the still indistinct forms of all the columns and the vestibules, amongst which I had seen the evil spirits weaving their funereal dances throughout the night. I sought Myrthé; but she had abandoned her harp and, motionless between Thelaire and Theis, she allowed a cheerless and cruel gaze to linger upon the sleeping warrior. Suddenly Meroé thrust her way forward among them: she had removed the golden asp from her arm, and it hissed as it slithered beneath the vaults; the echoing *rhombus* spun and whirred; Smarra, summoned for the departure of the morning's dreams, had come to claim the reward promised by the queen of night-time terrors, and was fluttering beside her with a hideous display of affection, his wings humming so fast that they did not darken the brightness of the air with the slightest shadow. Theis, Thelaire and Myrthé were dancing, all dishevelled, and uttering cries of glee. Near me, frightful children with white hair and wrinkled foreheads, and dull eyes, were seeking diversion by tying me to my bed with the frailest gossamer spun by the spider which casts its treacherous web between two adjacent walls to catch some poor straying fly. Some were collecting those silky white threads whose light filaments escape the fairies' miraculous spindle, letting them fall with all the weight

of a lead chain upon my pain-racked limbs.

'Arise', they were ordering me with insolent laughter, shattering my already crushed chest by beating it with a straw bent into the form of a flail, which they had stolen from a gleaner's sheaf. Meanwhile I was trying to disengage my hands from the frail bonds which held them, hands once redoubtable to the enemy and whose power had often been felt by the Thessalonians in the cruel games of the cestus and the boxing ring; my much-feared hands, those hands skilled in lifting the death-dealing iron cestus, were lying slackly on the unarmed chest of the weird dwarf, like a storm-tossed sponge at the foot of an age-old rock which the sea had assailed unavailingly since the dawn of time. In just such a way does the myriad-coloured globe, that dazzling, fleeting child's plaything, vanish without trace, even before skimming the obstacle towards which the eager childish breath propels it.

Polemon's scar was oozing blood and Meroé, drunk with desire, was raising the soldier's torn heart, which she had just ripped from his chest, above the avid group of her companions. She withheld the fragments from the blood-crazed young girls of Larissa, taunting them the while. Swooping and hissing, Smarra protected the dread conquest of the queen of nocturnal terrors. With the tip of his proboscis, whose long spiral uncoiled like a spring, he caressed Polemon's bloody heart, to beguile his eager thirst awhile; and Meroé, the beautiful Meroé, basked in his love and watchfulness.

The bonds which held me had yielded at last, and I found myself on my feet, awake now, at the foot

of Polemon's bed, while all the demons fled, along with all the sorceresses, and all the illusions of the night. My very palace, and the young slaves who were its ornament, all that transient panoply of dreams, had given way to the tent of a warrior wounded beneath the walls of Corinth, and to the mournful cortège of the officers of death. The funeral torches were beginning to fade before the rays of the rising sun, the death knell began to toll beneath the underground vaults of the tomb. And Polemon... O despair! In vain my trembling hand sought out a feeble flicker in his breast. — His heart would beat no more. His breast was empty.

SMARRA OR THE DEMONS OF THE NIGHT

EPILOGUE

Hic umbrarum tenui stridore volantum
Flebilis auditur questus, simulacra coloni
Pallida, defunctasque vident migrare figuras.

(Here one hears the lamentable groans of souls who fly
with a slight whistling sound; the peasants watch the
pale spectres and phantoms of the dead as they pass
by.)

Claudian

I may never believe
These antique fables, nor these fairy toys.
Lovers and madmen have such seething brains,
Such shaping fantasies, that apprehend
More than cool reason ever comprehends.

(*Midsummer-Night's Dream*, Act V, Scene I)

Ah! Who will come and break their daggers, who can staunch the blood of my brother and recall him to life? O! What have I come to seek for here? Undying pain! Abhorred Larissa, Thessaly, Tempe, river Peneus! O Polemon, my Polemon!...

'In the name of our good angels, what are you saying, what are you murmuring of daggers and of blood? Who makes you stammer out such random words, or groan incoherently like a traveller being murdered in his sleep, to be aroused by death?... Lorenzo, my dear Lorenzo...'

Lisidis, Lisidis, was it you who spoke? In truth, I thought I recognised your voice, I thought the shadows were receding. Why did you leave me while I was witnessing Polemon's last sigh in my palace at Larissa in the midst of the sorceresses who dance for joy? See how they dance for joy!'...

'Alas, I know neither Polemon nor Larissa, nor the fearful joy of the sorceresses of Thessaly. I know only Lorenzo. To-day — have you so soon forgotten? — saw the first return of our wedding day; yesterday was the eighth day of our marriage... Look, look at the daylight, at Arona, at the lake and the sky of Lombardy...'

The shadows come and go, they threaten me, they speak angrily to me, they talk of Lisidis, of a pretty little house by the water's edge, and of a dream I had in a distant land... they grow, they threaten me, they shriek...

'What new reproach will you torment me with, oh jealous and ungrateful husband? Ah, I know that

you are trifling with my fears, that you are merely
seeking to excuse some infidelity, or trying out some
strange excuse to cover up some well-planned quarrel...
I shall speak to you no more.'

Where is Theis, where is Myrthé, where are the
harps of Thessaly? Lisidis, Lisidis, if I was not mistaken
in hearing your voice, your sweet voice, you must be
there beside me... you alone can deliver me from
Meroé's tricks and her vengeance... Free me from Theis,
from Myrthé, from Thelaire...

'It is you, O cruel one, who is carrying ven-
geance too far, and who wishes to punish me for having
danced too long with another, yesterday, at the dance
on Isola Bella; but if he had dared to speak to me of
love...'

By St Charles of Arona, may heaven forfend...
Could it indeed be true, my Lisidis, that we returned
from Isola Bella to the sweet sounds of your guitar, to
our pretty house in Arona? From Larissa, from Thessaly,
from the waters of Peneus, to the sweet sound of your
harp?

'Leave Thessaly, Lorenzo, awaken... see the rays
of the rising sun striking St Charles' great head. Listen
to the sound of the lake as it laps on the strand at the
foot of our pretty house in Arona. Breathe in the breezes
of the morning which bear all the scents of the garden
and the islands, all the murmurs of the dawning day on
their cool wings. The Peneus flows far from here...'

You will never understand what I suffered that
night on its banks. May nature curse that river, and
accursèd too be the fearful malady which caused my

63

mind to stray for hours longer than life itself amidst scenes of false delights and cruel terrors! It has stolen ten years of my life.

'I swear to you, your hair has not grown white... But another time, more watchful I shall tie one of my hands to your hand, I shall slip the other into your curls, I shall breathe in the breath of your lips all night and I shall fend off deep sleep in order ever to awaken you before the ill which troubles you has reached your heart... Are you asleep?'

Trilby

There can be none among you, my dear friends, who has not heard tell of the *drows* of Thule and the household elves or imps of Scotland, and who does not know that there are few rustic dwellings in those parts which do not number an elf among their visitors. Furthermore such a demon is spiteful rather than evil, and mischievous rather than spiteful; on occasion he may be odd or refractory, but often gentle and obliging, with all the good qualities and all the faults of a badly brought up child. He rarely frequents the dwellings of the rich, or wealthy farms with large numbers of servants; a more modest calling links his mysterious existence with the hut of the shepherd or the woodcutter. There, a thousand times more cheery than the brilliant parasites upon fortune, he enjoys provoking the old women who say ill-natured things about him during their long evening vigils, or troubling the sleep of maidens with incomprehensible but pleasing dreams. He is particularly at home in cattle byres, and loves to milk the village cows during the night, so as to savour the sweet surprise of early-rising cow-girls, when they arrive at daybreak and cannot understand by what miracle the neatly ranged milkpans are already brimming with rich, frothy milk. He might also cut capers on the horses, which whinny with joy as he rolls the long hair of their manes around his fingers or shines their gleaming rumps, or washes their delicate, sinewy legs with water as pure as crystal. During the winter, his favourite place is the domestic hearth and the soot-blackened pots on the range, for he makes his home in the chinks in the masonry, beside the cell where the

cricket sings. How often was Trilby, the pretty imp who
dwelt in Dougal's croft, seen leaping on the edge of the
blackened stones with his little fiery tartan and his
smoky plaid, trying to catch the sparks which leapt
from the brands and rose above the hearth in a glitter-
ing sheaf! Trilby was the youngest, the most gallant, the
most mignon of elves. You might travel all Scotland,
from the mouth of the Solway to the straits of Pentland,
without finding one which could rival him in wit and
sweetness. He was attributed only with pleasing deeds
and clever fancies. The noble-women of Argyll and
Lennox were so taken with him, that several of them
were pining with regret at no longer giving hospitality
to this elf who had captivated their dreams, and the old
laird of Lutha would have sacrificed even the rusty
claymore of Archibald, that Gothic jewel of his armoury,
in order to offer the elf to his noble spouse. But Trilby
cared little for Archibald's claymore, or the castles and
the noblewomen. He would not have left Dougal's croft
for the world, for he was in love with the brown-haired
Jeannie, the provocative ferrywoman of Loch Beau, and
he sometimes took advantage of the fisherman's absence
to tell Jeannie of the feelings she had inspired in him.
When Jeannie, back from the loch, had seen the wander-
ing light of the roving boat which bore her husband,
together with the hopes of a successful catch, straying
in the distance, as it vanished into some deep bight,
sailing behind some looming headland, she would
continue gazing from the threshold of the croft, then go
in, sighing. She would fan the coals, half whitened by
ash, and set her spindle turning, humming St Dunstan's

hymn, or the ballad of the ghost of Aberfoil; and as soon as her eyelids, heavy with sleep, began to veil her tired eyes, Trilby, emboldened by the drowsiness of his beloved, would leap lightly from his hiding-place. He would bound with child-like joy into the flames, sending up a cloud of fiery sequins; then, more timidly, he would approach the sleeping spinner. Sometimes, reassured by her even breathing, he would advance, retreat, advance again, venturing as far as her knee, brushing it lightly like a moth with the silent beating of its invisible wings. He would go to caress her cheek, roll up in the curls of her hair, hang weightless from her golden ear-rings, or rest upon her bosom murmuring in a voice softer than the sigh of the breeze upon an aspen leaf:

'Jeannie, my lovely Jeannie, listen for a moment to one who loves you and who suffers in so doing, for you do not return his fondness. Take pity on Trilby, poor Trilby, your cottage elf. It is I, my lovely Jeannie, who tends the sheep you so cherish, and who keeps his coat as sleek as silk or silver. It is I who bears the weight of your oars to spare your arms, and who fends off the waves they have just touched. It is I who steadies your boat when it keels beneath the straining wind, and who makes it scud against the tide as on an easy slope. The blue fish of Loch Long and Loch Lomond, the ones whose dazzling backs sparkle like sapphires in the rays of the sun, beneath the shallow waters of the roadstead — it is I who brought them from the distant seas of Japan, to delight the eyes of the first girl-child you will bring into the world, and whom

you will see leaping about in your arms as she follows
their nimble movements and the rainbow reflections of
their gleaming scales. The flowers that surprise you at
morning on your path in the harshest season of the year
— it is I who flies to pluck them from the enchanted
lands whose existence you do not even dream of, and
where I could dwell, if I so wished, in smiling man-
sions, on beds of velvety moss which know not snow,
or in the sweet-scented chalice of a rose which shrivels
only to make way for lovelier ones still. When you
breathe in the scent of a tuft of thyme pulled from a
rock, and feel your lips surprised by a sudden move-
ment, like the flight of a bumble-bee, it is I, snatching a
kiss from you in passing. Your fondest dreams — those
where a child caresses you so lovingly — are sent to
you by me alone: I am that child whose lips, aflame, are
pressed by yours in the sweetest phantasms of the
night. Oh, make these dreams come true! Jeannie, my
lovely Jeannie, oh sweet enchantress of my thoughts,
object of fear and hope, trouble and ravishment, take
pity on poor Trilby, care for your cottage elf a little!'

Jeannie loved the elf's games, and his caressing
blandishments, and the innocently langorous dreams he
brought to her in her sleep. She had long taken pleasure
in this illusion without talking of it to Dougal, yet the
gentle face and plaintive voice of the spirit of the hearth
often came back to her thoughts, in that dim realm
between sleeping and waking where, despite itself, the
heart recalls the impressions it has strained to avoid
during the day. It seemed to her that she saw Trilby
skipping between the folds of her curtains, or that she

heard him weep upon her pillow. Sometimes indeed, she had thought she felt the presence of a feverish hand, the ardour of a burning mouth. At last she complained to Dougal of the obduracy of the demon who loved her, and who was not unknown to the fisherman himself, for this cunning rival had snagged his fish-hook a hundred times or draped the mesh of his net with the stealthy grasses of the lake. Dougal had seen him going before his boat in the shape of an enormous fish, distracting the patience of his night-time fishing vigils with deceiving insolence, then skimming the lake's surface in the form of a fly or moth, and vanishing on to the shore into the deep ranks of lucerne grass. It is thus that Trilby led Dougal astray, and prolonged his absences.

One may imagine Trilby's anger, and his concern, and his terror, as Jeannie, seated at the corner of the hearth, told her husband of the wiles of the mischievous elf! The half-burnt logs threw out white flames, which danced above them without touching them; the coals gave out little sparkling aigrettes, and the sprite rolled himself up in burning ashes and sent them flying around him in white-hot whirlwinds.

'Hope is at hand,' said the fisherman. 'This evening I met old Ronald, the learned monk from Balvaig, who understands the writings of the Church and who has not forgiven the imps of Argyll for the havoc they wrought last year upon his presbytery. Only he can rid us of that elf-shot Trilby, and banish him to the rocks of Inisfail, where these evil spirits dwell.'

It was not yet daybreak when the hermit was called to Dougal's croft. Throughout the daylight hours

he was absorbed in prayer and meditation, kissing the relics of the saints, and leafing through the ritual and Clavicula. Then, when night had quite fallen, and the wandering elves has once more taken possession of their solitary dwelling-places, he came to kneel before the glowing hearth; he threw into it some branches of consecrated holly, which crackled as they burned; he listened attentively to the melancholy song of the cricket who sensed the imminent loss of his friend, and recognised Trilby by his sighs. Jeannie had just come in.

Then the old monk stood up and uttered Trilby's name three times in stentorian tones.

'I adjure you,' he said, 'by the power I have received from the sacraments, to leave the croft of Dougal the fisherman when I have sung the holy litanies of the Virgin for the third time. As you have never given rise, Trilby, to any serious complaint, and indeed as you were even known in Argyll as the spirit without malice; and as I know (from the holy books of Solomon, whose understanding is particularly reserved to our monastery at Balvaig) that you belong to a mysterious race whose destiny is not irreparably fixed, and as the secret of your salvation or damnation is still hidden in the thoughts of the Lord, I shall refrain from pronouncing a harder punishment. But remember, Trilby, that I adjure you, in the name of the power the sacraments have given me, to leave the croft of Dougal the fisherman, when I have sung the holy litanies of the Virgin for the third time!'

And the old monk sang them for the first time, accompanied by the responses of Dougal and Jeannie,

whose heart was beginning to beat with painful emo-
tion. She was not without regret at having told her
husband of the elf's timid attentions, and the banishing
of the hearth's customary guest caused her to under-
stand that she was more attached to him than she had
previously believed.

The old monk again pronounced Trilby's name
three times: 'I adjure you,' said he, 'to leave the croft of
Dougal the fisherman and, in order that you may not
delude yourself that you may circumvent the meaning
of my words, I hereby inform you that this sentence is
irrevocable...'

'Alas,' said Jeannie in a low voice.

'That is,' the monk continued, 'unless Jeannie
herself permits you to return.'

Jeannie listened more closely.

'And Dougal himself summons you back.'

'Alas', repeated Jeannie.

'And remember, Trilby, that I adjure you, in the
name of the power the sacraments have given me, to
leave the croft of Dougal the fisherman, when I have
twice more pronounced the holy litanies of the Virgin.'

And the old monk sang for the second time,
accompanied by the responses of Dougal and Jeannie
who was speaking with only half a voice, her head half-
wrapped in her black hair, for her heart was swelling
with a weeping which she sought to contain, and her
eyes were bright with tears, which she sought to
conceal.

'Trilby,' she said to herself, 'does not come of
accursed stock; this monk himself has just admitted as

73

much; he loved me with the same innocence as my sheep; he could not do without me. What will become of him on this earth when he is deprived of the sole joy of his long evenings? Was it so bad a thing for poor Trilby to have played with my spindle of an evening when, half-asleep, I let it fall from my hand, or that he should have rolled in the thread I had just touched, covering it with kisses?'

But the old monk, repeating Trilby's name thrice more, also repeated his words:

'I adjure you,' he said, 'in the name of the power which the sacraments have given me, to leave the croft of Dougal the fisherman, and I forbid you ever to return, except on the condition I have just laid down, when I shall once more have sung the holy litanies of the Virgin.'

Jeannie raised her hands to her eyes.

'And you should know that I shall punish your rebellion in a manner which will alarm all your kind! I shall tie you up for a thousand years, wicked and disobedient spirit, in the trunk of the strongest and most gnarled birch-tree in the cemetery!'

'Unhappy Trilby,' said Jeannie.

'I swear it by God himself,' continued the monk, 'and thus it shall be done.'

And he sang for the last time, accompanied by Dougal's responses. Jeannie remained silent. She had let herself fall upon the projecting stone which bordered the hearth, and the monk and Dougal attributed her emotion to the natural sense of awe which an imposing ceremony needs must arouse. The last response died

away; the flames faded from the fire-brands: a blue light ran over the dead embers and disappeared. A long cry echoed through the rustic chimney. The elf had gone.

'Where is Trilby?' asked Jeannie, returning to her senses.

'Gone,' said the monk, with pride.

'Gone!' she replied, in tones he took for joy and admiration. The holy books of Solomon had not taught him these mysteries.

Hardly had the elf left the threshold of Dougal's croft, than Jeannie felt bitterly that poor Trilby's absence had made it a deeply lonely place. No longer did she sing of a dark evening; indeed, certain that she was committing her refrains to unfeeling walls alone, she no longer sang at all except in moments of forgetfulness or at those rare moments when she fleetingly thought that Trilby, more powerful than Clavicula or ritual, had perhaps out-tricked the old monk's exorcism and the severe sentence of Solomon. Then, her gaze fixed upon the hearth, she tried to discern some of the features which her imagination had lent to Trilby in the eerie figures drawn by the ashes in sombre sections of the dazzling fire; she saw only a formless, lifeless shadow which broke up the uniformity of the burning red of the hearth here and there, and which scattered at the slightest movement of the tuft of dry heather she would wave in front of the fire to bring it back to life. She would let fall her spindle, and would abandon her thread; but Trilby would no longer roll it before him as though to hide it from its mistress, then willingly return it to her and use it, scarcely had she taken hold of it

once more, to climb up to Jeannie's hand and deposit a quick kiss; and then he would leap down again so promptly, and flee and disappear, that she never had the time to take fright and deplore the deed. Alas! How times had changed! How long the evenings, and how sad her heart!

Jeannie's nights had lost their charm, as had her life; and they were further saddened by the secret thought that Trilby, receiving a warmer welcome from the noblewomen of Argyll, was living amongst them, cosseted and peaceful with no fear of their cruel husbands. Every moment of his delicious evenings, it seemed to her, must afford a humiliating comparison with the croft on Loch Beau; evenings spent in front of sumptuous mantlepieces where black columns of Staffa basalt rose from silver Firkin marble to soar upwards towards vaults glittering with rainbow chandeliers! It was a far cry from this magnificence to the simplicity of Dougal's cheerless hearth. And this comparison was all the more painful for Jeannie, when she imagined her noble rivals clustered around a fire whose heat was maintained by precious and sweet-smelling woods, which filled the castle favoured by the imp with a scented cloud! Then she listed to herself the richness of their attire, the brilliant colours of their chequered dresses, the careful grace of their coiffures, the beauty and elegance of their ptarmigan and heron feathers, and seemed to hear snatches of their voices, exquisitely married to some ravishing harmony, borne on the air!

'Unhappy Jeannie,' she said, 'so you thought you could sing! Had you a voice sweeter than that of the

young mermaid the fishermen have sometimes heard in
the morning, what have you done, Jeannie, that he
might remember it? You sang as though he were not
there, as though only the echo were listening, while all
those coquettes sing for him alone; furthermore, they
have so many advantages over you: fortune, nobility,
perhaps even beauty! You are dark, Jeannie, for your
forehead, exposed to the burning surface of the waters,
braves the burning sky of summer. Look at your arms:
they are supple and sinewy, but they have neither
delicacy nor bloom. Your hair may lack grace, but it is
long, dark and superbly curly when you abandon it
loose on your shoulders to the cool breezes of the loch.
Yet he has seen you there so rarely, and might he not
already have forgotten that he ever saw you?'

　　Preoccupied with these thoughts, Jeannie fell
asleep later than usual, and indeed did not taste sleep
itself, passing from unquiet wakefulness to a new
inquietude. Trilby no longer appeared in her dreams in
the imaginary form of the graceful imp of the hearth.
The capricious child had been succeeded by a blond
adolescent, whose slender, willowy form might compete
in elegance with the slightest reed at the loch's edge; he
had the sweet, fine features of the imp, but grown now
into the impressive traits of the chief of the MacFarlane
clan, when he climbed the Cobbler brandishing the
redoubtable hunter's bow, or wandered over the swards
of Argyll, the strings of his Scots' harp echoing from
dell to dell; and such must have been the last of those
illustrious lords, when he suddenly disappeared from
his castle on being cursed by the holy monks of Balvaig

for having refused to pay an ancient tribute to the monastery. But Trilby's gaze no longer had the openness, the innocent trustfulness of happiness. That naive and candid smile no longer played upon his lips. He regarded Jeannie with a saddened air, sighed bitterly, and pulled his curls over his forehead, or covered it with the long folds of his cloak; then he would vanish into the dim shadows of the night. Jeannie's heart was pure, but she suffered at the idea that she was the sole cause of the sufferings of a charming creature who had never caused her harm, and whose innocent fondness she had feared too hastily. She imagined, in the unbidden delusion of dreams, that she was calling upon the elf to return, and that, overcome with gratitude, he threw himself at her feet and covered them with kisses, and tears. Then, looking upon him in his new form, she realized that any interest she might take in him would indeed be blameworthy, and deplored his exile without daring to hope for his return. Thus had Jeannie passed her nights since the departure of the imp; and her heart, embittered by a justified sense of repentance and haunted by an unwilling attraction, ever repulsed yet ever triumphant, was concerned only with dismal worries which had troubled the repose of the croft. Dougal himself had become restless and abstracted. There are privileges attaching to the places where elves dwell! They are safe from the accidents of storm and the ravages of fire, for the attentive imp never forgets, when everyone has yielded themselves up to sleep, to do his nightly round of the hospitable domain which offers him a haven from the winter's cold. He tightens the

bundles of thatch as the stubborn wind loosens them, or
puts a storm-shaken door back on its hinges. Obliged to
tend the pleasant warmth of the hearth on its own
behalf, he sometimes rakes aside the ash as it piles up;
with a light breath he kindles a spark which gradually
creeps over a waiting coal, and which soon spreads
throughout its darkening surface. That is all he needs to
warm himself; but he pays generously for this kindness
by watching to see that no furtive flame should spread
during his hosts' heedless sleep; he peers into the least
recesses of the dwelling, all the chinks of the old
fireplace; he turns over the fodder in the manger, the
straw in the litter; nor is his solicitude limited to care of
the cattle byre: he also protects the peaceful denizens of
the farmyard and hen-run, whose only God-given
protection is their cries, and which have been left quite
unarmed. Often the leopard-cat, who had come down
from the mountains athirst for blood, barely dinting the
muffling moss with his light tread, curbing his tiger's
whine, veiling his burning eyes which shine like wan-
dering beacons in the night; often the roaming marten,
which falls upon its prey and seizes it without inflicting
harm, smothering it flirtatiously with sweet attentions,
intoxicating it with ravishing scents and then imprinting
a deadly kiss upon its neck; often the fox himself has
been found lifeless beside a peaceful nest of fledglings,
while an unmoving mother sleeps, her head beneath her
wing, dreaming of happy days for all her safe-hatched
brood. Lastly, Dougal's situation had been greatly eased
by the catching of those pretty blue fish which let
themselves be caught by his net only; and since Trilby's

79

departure, the blue fish had gone. Thus he could no longer come to the shore without being dogged by the reproachful shouts of all the children of the MacFarlane clan:

'Wicked Dougal, it is you who has taken away all the pretty little blue fishes of Loch Long and Loch Beau; no longer shall we see them leap to the surface of the water, as though pretending to rise to our bait, or pausing motionless, like misty flowers, on the rosy grasses of the roadstead. No longer shall we see them swimming beside us when we bathe, warding off dangerous currents by deft flicks of their long blue bodies...'

And Dougal would continue on his way, muttering; sometimes he even said to himself:

'It may indeed be ridiculous to be jealous of an imp; but the old monk of Balvaig knows more about it than I do.'

But Dougal could not deceive himself as to the recent change in Jeannie's character, once so serene and playful; and he never thought back to the day when he had seen that melancholy descend, without at the same time remembering the ceremonies of Trilby's exorcism and exile. By dint of reflection, he convinced himself that the worries which assailed his household, and the bad luck which dogged him in his fishing, might well be the effect of a spell, and without communicating this thought to Jeannie in terms which might exacerbate the bitterness of the worries with which she seemed beset, he gently informed her of his desire to have recourse to some powerful protection against this persistent bad

luck. A few days later the famous vigil of St Columban was to take place at the monastery of Balvaig: Columban was a saint whose intercession was more sought after than any other by the young women of the region because, the victim of a sad and secret love, he was probably more kindly-disposed to the heart's hidden sufferings than any other denizen of the celestial courts. He was said to have performed miracles of charity and tenderness; tales which Jeannie never heard without emotion, and for some time now they had come frequently to her mind amidst the gentle dreams of hope. She yielded all the more willingly to Dougal's suggestion in that she had never visited the uplands of Callander; and thus that region, new to her eyes, seemed likely to hold fewer haunting memories than the croft hearth, where everything spoke to her of Trilby's graces and innocent love. One single grief was mingled with the idea of this pilgrimage: that the elder of the monastery, the inflexible Ronald whose cruel exorcism had banished Trilby for ever from her modest and lonely existence, would probably come down in person from his hermitage in the mountains, to take part in the celebrations of the feast of the patron saint; but Jeannie, who feared all too justifiably that she had many indiscreet thoughts and perhaps even sinful feelings to reproach herself with, promptly resigned herself to the mortification and chastisement of his presence. Besides, what was she going to ask of God if not to forget Trilby, or rather to forget the false image she had made of him; and what grudge could she harbour against this old man, who had done no more than fulfil her wishes and

hasten her repentance?...

'In any case,' she continued to herself, unaware of any illogicality of thought, 'Ronald was over a hundred years old when the leaves last fell, and maybe he is dead.'

Dougal, less preoccupied in that he was far more intent upon the object of his journey, was calculating what advantage the more cunning fishing of those blue fish, whose species he had believed to be inexhaustible, might bring him in the future; and as though he thought that the mere project of a pious visit to the tomb of the holy abbot might once more attract this vagabond tribe to the low waters of the bay, he plumbed them fruitlessly with his gaze, making the little detour at the extremity of Loch Long, towards the lovely shores of Tarbet, an enchanted region which even the traveller who has crossed them with a heart empty of those illusions of love which render all landscapes more beautiful, can never forget. It was a little less than a year since the elf had been so firmly banished. Winter had not begun, but summer was drawing to a close. The leaves, buffeted by the chill morning breeze, were beginning to wither at the tips of the bowed branches, and their weird clusters, struck by a brilliant red, or mottled with tawny gold, seemed to bedeck the trees with fresher flowers or brighter fruit than the flowers or fruit they had received from nature. There seemed to be bunches of pomegranates in the birch trees, and ripe clusters of grapes hanging from the pale greenery of the ash, glowing suddenly amidst the delicate outline of their slight foliage. Such days of autumnal decline hold

a strange mystery which adds to the gravity of all our moods. Then each step which time takes over the fields as they fall bare, or on the foreheads of the yellowing trees, imparts a further sign of transience, graver and sterner still. From the depths of the woods comes a threatening sound compounded of the creaking of dry leaves and the confused wails of beasts of prey alarmed for their little ones by the foreboding of a hard winter: sighs, groans, sounds sometimes resembling human voices, which surprise the ear and catch at the heart. Even in the sheltered church the traveller cannot escape the sensations which pursue him. The vaults of the old buildings utter the same noises as the depths of the old forests when the foot of the solitary passer-by sounds out the sonorous echoes of the nave, and the outside air which creeps between the ill-joined boards or stirs the lead of the broken window adds eerie chords to the muffled resonance of its passing. Sometimes it puts one in mind of the high-pitched song of a cloistered young virgin answering the majestic booming of the organ; and these impressions mingle so naturally in autumn, that even the instincts of animals are deceived. Wolves have been seen wandering trustingly among the columns of an abandoned chapel as though amidst the spectral boles of birches; a flight of dazed birds settles raggedly on the tops of tall trees, as on the pointed steeples of old churches. At the sight of that soaring mast, whose form and substance are stolen from its native forest, the kite gradually narrows the orbits of its circling flight, and perches upon its sharp point as on an armorial pale. All this should have warned Jeannie

against a distressing premonition she experienced as she arrived, on Dougal's heel, at the chapel of Glenfallach, whither they had gone first, for that was the pilgrims' meeting place: there, from afar, she had seen a huge-winged rook sink down upon the ancient spire, and pause with a prolonged cry which expressed such disquiet and suffering that she could not help regarding it as a sinister portent. Growing more timid as she approached, she cast her gaze around her at random, and her ear took fright, alarmed even at the faint lapping of the feeble waves which came to die at the foot of the abandoned monastery.

Thus, from ruin to ruin, Dougal and Jeannie reached the narrow banks of Loch Katrine; for, in those far-off days, ferrymen were fewer, and the stops of the pilgrims more frequent. At last, after three days of journeying, they saw in the distance the fir trees of Balvaig, their dark greenery standing out with pictur-esque boldness amidst the withered forests and the background of the pale mosses of the mountain. Above its arid flank, as though propped upon the summit of a perpendicular rock whence they seemed about to hurtle into the abyss, the old and blackened towers of the monastery could be descried, and the wings of the half-ruined buildings extending backwards behind it. No human hand had repaired the ravages of time since the saints had founded it; according to a widespread tradition, when its awesome remains finally ceased strewing the ground with their debris, the enemy of God would triumph for several centuries in Scotland, casting an impious shadow over the pure splendours of

faith. Thus it was a source of never-failing joy for the Christian multitude to see it standing, imposing as ever, and offering some promise of permanence. Cries of delight, shouts of enthusiasm and gentle murmurs of hope and gratitude mingled in their proffered prayers. It was then, at that moment of deep and pious emotion, that the kneeling pilgrims summed up the main aims of their journey during a few minutes' worship: for the wife and daughters of Coll Cameron, one of Dougal's nearest neighbours, new finery which would eclipse Jeannie's simple beauty at the imminent festivities; for Dougal, a miraculous draught of fishes which would enrich him with a certain treasure, contained in a precious box which his good fortune would bring to him intact at the loch's edge; and for Jeannie, the need to forget Trilby, to dream of him no more; but this was a prayer which her heart could not endorse in its entirety, and which she set aside to meditate upon further at the foot of the altar, before yielding it up unreservedly to the attentive thought of the protecting saint.

At last the pilgrims arrived at the parvis of the old church, where one of the oldest hermits of the region would habitually await their offerings, and present them with refreshments and shelter for the night. From a distance, the dazzling whiteness of the anchorite's forehead, the height of his majestic figure, unbowed by the weight of years, the gravity of his attitude, motionless and almost threatening, had struck Jeannie with a mingled sense of fear and respect. This hermit was Ronald, the severe and ancient monk from

Balvaig.

'I was expecting you,' he said to Jeannie so meaningfully that the luckless young woman could not have felt more disturbed had she heard herself publicly accused of a sin.

'And you too, my good Dougal,' he continued, blessing him; 'rightly have you come to seek the grace of heaven, and to ask us for protection against the secret enemies which torment you — a protection sorely tried by the sins of the people, and which can no longer be bought except by great sacrifice.'

While he was thus speaking, he had led them into the long refectory; the remainder of the pilgrims were resting on the stones around the entrance, or were scattered, each following his own particular devotion, amongst the numerous chapels of the underground church. Ronald crossed himself and sat down, Dougal did likewise; Jeannie, seized with a persistent disquiet, tried to evade the unflinching attention of the holy priest by allowing her own to wander over the new objects of curiosity which were offered to her gaze in this unknown place. Vaguely intrigued, she studied the vast arches of the ancient vaults, the majestically soaring pillars, the weird and complex work of the ornaments and the endless succession of dusty portraits in their battered frames which hung on the innumerable panels of the wainscotting. It was the first time that Jeannie had been in a picture gallery, the first time her eyes had been surprised by such seemingly living imitations of the face of man, enlivened at the artist's will by all life's passions. In wonderment, she contemplated this suc-

cession of Scots heroes, each so different in expression and character, and whose mobile gaze, ever fixed upon her movements, seemed to pursue her from painting to painting, some with a helpless interest and bootless pity, others with a menacing sternness and crushing look of malediction. One of them, whose resurrection had, one might almost say, been hastened by the brush of a particularly daring artist and whom a combination of effects and colours, uncommon for the time, seemed virtually to have thrust out of the canvas, so startled Jeannie that she seemed to see him leap forward from his frame of gold and cross the gallery like a spectre; she took refuge, trembling, with Dougal and fell silently upon the bench which Ronald had prepared for her.

'That,' said Ronald who had not stopped talking with Dougal, 'is the pious Magnus Mac-Farlane, the most generous of our benefactors, and the one who has the greatest share of our prayers. Angered by his descendants' lack of faith, which prolonged the suffering of his soul by centuries, he pursues their supporters and abettors even in this miraculous portrait. I have heard it said that the friends of the last Mac-Farlane never entered these premises without seeing the pious Magnus leap forth from the canvas where the painter thought he had confined him, to take vengeance upon them for the crimes and unworthiness of their clan. The empty spaces which follow,' he continued, 'are those which were reserved for the portraits of our oppressors, and from which they have been cast out, as from heaven.'

'And yet,' said Jeannie, 'the last of these spaces

seems occupied... There is a portrait at the end of this gallery, and were it not for the veil which covers it...'

'I was telling you, Dougal', continued the monk without heeding Jeannie's observation, 'that this portrait is that of Magnus Mac-Farlane, and that all his descendants are consigned to eternal damnation.'

'And yet,' repeated Jeannie, 'there is a portrait at the end of the gallery, a veiled portrait which would not be accepted in this holy place if the person represented in it were indeed committed to eternal damnation. Does it by any chance not belong to the family of the Mac-Farlanes, as the arrangement of the rest of this gallery seems to indicate, and how could a Mac-Farlane...'

'God's vengeance has its limits and conditions,' interrupted Ronald, 'and that young man must have had friends among the saints...'

'He was young!' exclaimed Jeannie.

'Well,' said Dougal severely, 'of what account is the age of a soul in torment?'

'The damned have no friends in heaven,' answered Jeannie quickly, making as if to go towards the painting.

Dougal restrained her, and she sat down. The pilgrims were filing slowly into the room, and gradually narrowing their vast circle around the seat of the venerable old man who had resumed his discourse with them where he had left off.

'It is true,' he was saying, his hands pressed to his bowed forehead. 'Great sacrifices are needed! We can call upon the Lord's protection through our intercession only for the souls which ask for it sincerely,

with no hint of guardedness or weakness. It is not enough to fear obsession by a demon and pray to heaven to deliver us from it. We must also curse him. Do you know that charity may be a great sin?'

'How can this be?' asked Dougal.

Jeannie turned to Ronald and looked at him with greater confidence than before.

'Unfortunates that we are,' continued Ronald, 'how could we withstand an enemy devoted to our downfall if we did not use all the resources religion has given us, all the powers it has put into our hands, to combat him? What use would it be to pray constantly for those who persecute us, if they do not cease their constant manoeuvres and their evil spells against us? The sacred hair-shirt of the holy ordeals does not of itself defend us against the workings of the evil one; we suffer as you do, my children, and we judge the rigour of your struggles by those which we ourselves have enjoined. Do you think that our poor monks have travelled so long a road on this earth — so rich in pleasures — leading a life of such studied austerity and want, without sometimes struggling against the taste for luxury and the desire for the temporal good which you call happiness? Oh what delicious dreams assailed our youth! What sinful ambitions tormented our ripe age! What bitter regrets hastened the whitening of our hair, and what weight of remorse would bow us down when we came into the presence of our maker, had we hesitated to arm ourselves with curses and vengeance against the spirit of sin!...'

At these words the old monk made a sign, the

crowd lined up on the narrow bench which ran like a moulding around the length of the walls, and he continued:

'Measure the greatness of our affliction by the depth of the solitude which surrounds us, by the immense abnegation to which we are condemned! The cruellest rigours of your destiny are at least not without consolation, indeed not without pleasure. You all have some soul who seeks you out, some intelligence which understands you, another being which is associated, through memory or interest or hope, with your past, present or future. Your thoughts can wander freely, no space is forbidden to your step, no creature to your affections; while the whole earthly life of the monk or hermit is bounded by the solitary threshold of the church and that of the sepulchre. The long unrolling of our changeless years is but a change of tomb, a walk from the monks' choir to that of the saints. Do you not think you owe some requital for so painstaking and persevering a devotion to your salvation? Well, my brothers, now you may know how much the zeal which binds us to your spiritual interests augments the austerity of our daily penance! You may know that it is not enough for us to be subjected, like the rest of mankind, to these demons of the heart, whose assaults not one of the children of Adam can defy. Even the most ill-favoured of spirits, the most obscure of imps takes a malign delight in bedevilling the fleeting instants of our repose and the calm of our cells, so long inviolable. Above all some of these shiftless elves whom we have expelled from your homes with such pains and

at the price of so much prayer, take cruel vengeance upon us for the power which an imprudent exorcism has caused us to lose. In banishing them from the secret dwellings they had usurped in your farms, we omitted to indicate a specific place of exile to them, and the houses from which we drove them alone are safe from their insults. Would you believe that they have no respect whatsoever for holy places, and that even as I speak their infernal cohort is merely awaiting the return of darkness to spread itself in swirls beneath the wainscotting of our cloister? The other day, at the very moment when the coffin of one of our brothers was about to touch the floor of the burial vault, the rope broke suddenly, whistling as though with bitter laughter, and the coffin rolled groaning from step to step beneath the vaults. The voices which came from it sounded like the voices of the dead, indignant that their graves had been disturbed — moaning, expostulating, crying out. The onlookers nearest the burial vault, who were beginning to peer into its depths, thought they saw tombs gaping and shrouds floating, and skeletons, disturbed by the tricks of the imps, leaping forth with them from the mouths of the tombs and wandering through the nave, mingling confusedly in the choirstalls and drifting macabrely through the shadows of the sanctuary. At the same instant, all the lights in the church... now harken!'

The crowd drew closer to listen to Ronald. Jeannie alone, running her fingers through her curls, her mind fixed on a single thought, listened, yet heard no more.

'Harken, my brothers, and tell us what secret sin, what act of betrayal or murder, what falsification of thought or deed could have brought this calamity upon us. All the lights in the church had gone out. The acolytes' torches gave out but a weak and wandering light which came and went, dancing in frail blue rays like sorceresses' magic brands, then rose upwards, becoming lost in the dark recesses of the entrance halls and chapels. Finally, the unquenchable lamp of the Holy of Holies itself... I saw it flicker, fade and die. Die! Deepest darkness, utter night fell upon church, choir and tabernacle alike. Darkness had fallen upon the Lord's sacrament for the first time! A dark so deep, so dank, so fearsome, everywhere; frightening and horrible beneath the dome of our basilicas, where promise is of an eternal day!... Our monks, bewildered, stumbled through the great church, made vaster still by the pitch blackness of the night. They were further confused by the walls which on all sides were denying them the narrow and forgotten portal whereby to leave the church. Baffled by the confusion of their plaintive voices reverberating and bringing sounds of menace and terror to their ears, they fled in alarm, attributing the clamour and moan to the grim sepulchral images they thought they heard keening on their beds of stone. One of them felt the chill hand of St Dunstan opening and closing upon his own, clamping him to his tomb in an eternal embrace. He was found there lifeless the following day. The youngest of our brothers (and recently arrived among us, so that as yet we knew neither his name nor family) clung so desperately to the statue of a young

female saint from whom he was hoping for help, that he brought it down upon him, and was crushed beneath it as it fell. You all know the statue — it was the one recently carved by a skilled sculptor of the region, in the likeness of that maiden of Lothian who died of grief because she had been separated from her betrothed.'

'So many misfortunes,' continued Ronald, seeking out Jeannie's gaze, 'may be the result of some misplaced pity, some unintentionally criminal intercession; of a sin, a single sin of intent.'

'Of a single sin of intent', chimed Clady, the youngest of Coll Cameron's daughters.

'Of one alone!' repeated Ronald impatiently.

Unheeding and serene, Jeannie had not even sighed. The incomprehensible mystery of the veiled portrait claimed her whole attention.

'And therefore,' said Ronald, rising, and imparting a solemn exaltation and authority to his words, 'we have set aside this day to strike the evil spirits of Scotland with an irrevocable curse.'

'Irrevocable,' murmured a moaning voice, which gradually faded away.

'Irrevocable, if it is freely made and universal. When the cry of malediction rises before the altar, if all voices repeat it...'

'If all voices repeat a cry of malediction before the altar!' echoed the voice.

Jeannie was walking towards the end of the gallery.

'Then all will be over, and the demons will plunge once more and for ever into the abyss.'

93

'So be it!' chimed the company.

En masse they followed that mighty scourge of imps. The other monks, either more timid, or less severe, had declined to attend this redoubtable and cruel ceremony; for we have already said that the elves of Scotland, whose eternal damnation was not an established point of popular belief, inspired disquiet rather than hatred, and a rumour had spread that some amongst them were braving the rigours of exorcism and the threats of anathema in the cell of some charitable hermit or in the niche of some apostle. As to the fishermen and shepherds, for the most part they had nothing but praise for these familiar intelligences, suddenly so mercilessly condemned; yet, forgetful of past services, they willingly joined themselves to Ronald's outrage, and did not hesitate to proscribe this unknown enemy who had revealed himself only through his kindness.

Furthermore the story of poor Trilby's exile had come to the ears of Dougal's neighbours, and during the evening vigils Coll Cameron's daughters often told each other that it was probably to one of his tricks that Jeannie owed her success at the clan's festivities, and Dougal his advantage over their lovers and father at fishing. Had not Maineh Cameron seen Trilby himself, seated at the prow of the boat, throwing armfuls of blue fish into the empty nets of the sleeping fisherman, waking him by tapping the boat with his foot and rolling to the shore from wave to wave, in a silver foam?

'A curse,' cried Maineh.
'A curse,' said Feny.

'Ah! Jeannie alone enthrals you with her beauty', thought Clady. 'It is for her that you left us, phantom of my sleep, whom I loved only too well, and if the curse pronounced against you is not fulfilled, free still to choose among all the crofts of Scotland, you will again settle upon that of Jeannie! It shall not be!'

'A curse,' repeated Ronald in a terrible voice.

Clady was still an unwilling participant, but Jeannie returned looking so radiant with love and emotion that she could hesitate no more.

'A curse!' said Clady.

Jeannie alone had not been present at the ceremony; but the rapid succession of so many deep and vivid impressions had at first prevented her absence from being noted. Yet Clady observed it, for she thought she had no equal in beauty. Here we should recall that a lively curiosity had attracted Jeannie towards the end of the gallery of paintings just at the moment when the old monk was convincing his audience to fulfil the cruel duty which their piety demanded of them. Scarcely had the crowd streamed out of the room than Jeannie, quivering with impatience, and perhaps also preoccupied despite herself with another emotion, rushed towards the veiled picture, tore away the curtain in front of it, and recognised all the features she had dreamed of. It was he. It was the well-known face, the garments, the weapons, the shield, even the name of the Mac-Farlane clan. Beneath the portrait, in accordance with the custom of his time, the old painter had traced the name of the man portrayed:

JOHN TRILBY MAC-FARLANE

'Trilby!' cried Jeannie overwhelmed.

Fleet as lightning, she ran through halls and galleries, up flights of stairs, along passages and vestibules, and fell at the foot of the altar of St Columban at the very moment when Clady, trembling with the effort of self-mastery, was concluding her proffered cry of malediction.

'Charity,' cried Jeannie, embracing the holy tomb.

'LOVE AND CHARITY,' she repeated in a lower voice.

And if Jeannie had lacked the courage for charity, the image of St Columban would have sufficed to rekindle it within her breast. Without seeing the sacred portrait of the monastery's protector one would have no idea of the divine expression which the angels had imparted to the miraculous canvas, for it is universally known that this painting was not drawn by human hand, but that a spirit had come down from heaven, while the artist had fallen asleep, to beautify the angelic features of the blessed man with the most tender feeling of piety, and with a charity which the earth knows nothing of. Among all the Lord's elect, only St Columban's gaze was sad and his smile bitter, either because he had left behind him on this earth the object of an affection so dear that the ineffable joys promised for an eternity of glory and happiness were powerless to banish it from his mind, or because, too sensitive to the sufferings of humanity, in his new state he felt only the inexpressible pain of seeing those unfortunates who outlived him exposed to so many perils, and delivered

over to so much anguish, which he could neither stave off nor console. Such must indeed be the only afflictions of the saints, unless the events of their life have perchance bound them to the destiny of a creature now lost to them and which they will never see again. The sweet brightness which shines forth from the eyes of St Columban, the utter benevolence exhaled by his life-like lips, the emanations of love and charity which dispose the heart to a religious tenderness, all strengthened Jeannie's already dawning resolve; she repeated to herself more forcefully still: LOVE AND CHARITY.

'By what right,' said she, 'would I pronounce a sentence of malediction? Surely this is not the right of a mere woman, and it is not to us that the Lord has entrusted the care of His terrible vengeance. Perhaps He does not take vengeance at all! And if He has enemies to fear, it is not to the blind passions of His weakest creatures (all of whose thoughts He must one day judge) that He can have entrusted the most terrible ministry of His justice... How would I implore His pity for my faults, when they are revealed to Him by evidence, alas, which I cannot gainsay, if, for faults which are unknown to me, for faults indeed which perhaps have not been committed, I offer up the terrible cry of malediction which I am being asked to make against some unfortunate who has already perhaps been only too harshly treated.'

Here Jeannie took fright at her own supposition, and she raised her gaze towards that of St Columban only with alarm; but, reassured by the purity of her feelings, for the irrepressible interest she took in Trilby

never made her forget that she was Dougal's wife, she sought to divine the elusive thoughts of the saint of the mountains, fixing her eyes and thoughts upon him. A faint ray of the setting sun, filtering through the stained-glass windows and falling upon the altar with all the tender and brilliant colours of the rainbow, enhanced by the twilight, lent the blessed soul a brighter radiance, a calmer smile, a deeper serenity, a fuller joy. Jeannie felt that St Columban was glad and, full of gratitude, she pressed her lips to the paving of the chapel and the steps of the tomb, repeating her vows of charity. It is even possible that she then offered up a prayer which could not be answered on earth. Who will ever penetrate all the secrets of a tender soul, and who could appreciate the devotion of a woman in love?

The old monk, who was observing Jeannie closely and who, satisfied with her emotion, did not doubt that she had answered his hopes, raised her from the sacred parvis and returned her to the care of Dougal, who was preparing to depart, already laden, in his imagination, with all the goods he was counting upon as a result of a successful pilgrimage, and of the protection of the saints of Balvaig.

'Nonetheless,' he said to Jeannie as the croft came into view, 'I cannot disguise the fact that the curse cost me dear, and that I shall need to distract myself from the thought of it by going fishing!'

But for Jeannie there was no possibility of distraction: nothing could now distract her from her memories.

The day after the ferrywoman had accompanied

the family of the laird of Roseneiss in the direction of
the Bay of Clyde, she was returning to the end of Loch
Long at the mercy of the tide: it drove her boat at an
equal distance from the quicksands of Argyll and
Lennox, so that she had no need of the wearisome use
of the oars. Standing on the narrow, nimble boat, she
loosed the long black hair of which she was so proud;
her neck, whose whiteness the sun had lightly touched,
but not coarsened, rose in all its beauty above her red
dress. Her bare foot, resting on one of the sides of the
frail vessel, balanced it lightly so as to parry the slight
swell, and the waves, stirred by this almost impercep-
tible resistance, returned seething and rose, frothing, to
the height of Jeannie's foot, rolling their fleeting foam
around it. The season was still harsh, but there was a
sense of imminent mildness, and the day appeared to
Jeannie one of the loveliest she could recall. The mists,
which usually rise up from the loch and spread before
the mountains like a curtain of crepe, had now dis-
persed their filmy mesh. Those which the sun had still
not entirely dissipated were rocking in the west like a
web of gold spun by the fairies of the loch for the
adornment of their merrymaking. Others were strewn
with shifting, glistering points, dazzling as sequins,
scattered over a transparent backdrop of marvellous
colours. These were small moist clouds where orange,
pale yellow and a light green struggled, according to
the whim of the wind or sunbeam, for predominance
over azure, mauve or violet. At the clearing of a wan-
dering haze, at the disappearance of a shoreline aban-
doned by the current, everything would merge into an

indefinable and nameless softness which caught the spirit in a sensation so novel that one might have imagined that one had just acquired a sixth sense; and during that time the motley decor of the shore was paraded before the eyes of the ferrywoman. There were vast domes which ran before her, on whose rounded flanks fell all the glory of the setting sun, making them appear now bright as crystal, now matt grey and unobtrusive as iron, rimmed at their peak by haloes of bright pink which grew gradually paler as they sank down the chill sides of the mountain and died away at its base in fading shadows. There were forelands of deep black which might have been mistaken for unavoidable reefs, but which suddenly retreated before the prow and revealed broad bays favourable to boatmen. The feared reef was receding, and now all took on the sense of ease given by a safe return from sea. In the distance Jeannie had seen the wandering barks of the famed fishermen of Loch Goyle. She had beheld the fragile buildings of Portinacaple. With an emotion that was reborn daily, she again contemplated the crowd of peaks which succeeded one another, piled upon one another or intermingling, and separated only by some unexpected play of light, particularly in the season when they were blanketed beneath a monotonous covering of snow, and the silvery silk of peat moss, and the dark mantling of the granite, and the pearly scales of the reefs. To her left, so limpid was the sky, she thought she could make out the great domes of Ben-More and Ben-Neathan; to her right, the sharp summit of Loch Lomond, distinguished by the dark protrusions

where the snow had not settled, and which riddled the bald pate of the king of mountains with sombre ridges. The furthest plane of this tableau reminded Jeannie of a tradition widespread in the region, and one which her spirit, now more disposed than ever to fantastical emotions and outlandish ideas, recast in a new way. At the very tip of the loch the vast mass of Ben-Arthur rises skyward, topped by two black basalt rocks, one of which seems to lean upon the other like the worker on the stand where he has set the tools of his daily trade. These colossal stones had been brought from the caverns of the mountain reigned over by Arthur the giant, when bold men came to raise the walls of Edinburgh on the shores of the Forth. Banished from his lofty solitude by the skills of a rash people, Arthur took a step towards the end of Loch Long, and set the ruins of his rough palace upon the highest mountain that rose before him. Seated on one of its rocks with his head resting on the other, he cast furious looks upon the godless ramparts which were usurping his domain and separating him for ever from happiness and even from hope; for it is said that he had known an unrequited love for the mysterious queen of these shores, one of those fairies whom the ancients called nymphs and who inhabit enchanted caves carpeted with flowers of the deep, and lit by the light of the pearls and carbuncles of the Ocean. Unhappy the venturesome boat which skimmed the surface of the still lake, when the long figure of the giant, insubstantial as the evening mist, rose up suddenly between the two rocks of the mountain, placed his mis-shapen feet upon their unequal

summits, and swayed at the mercy of the wind, stretching out shadowy hands over the horizon, finally to clasp it in a broad embrace. Scarcely had his cloak of cloud dipped its lowest folds into the loch, than the fearsome eyes of the phantom would send forth a flash of lightning, his terrible voice would give out a rumble of thunder, and the waters would ravage their shores. His appearance, dreaded by fishermen, had emptied the rich and smiling roadsteads of Arrochar. But one day a young hermit, whose name has been lost to posterity, arrived from the stormy seas of Ireland, alone, but invisibly escorted by a spirit of faith and charity, upon a bark driven by an irresistible power and which ploughed the great waves untouched by their agitation. On his knees on his frail craft, he held a cross in his hands and kept his eyes upon the heavens. Reaching the goal of his journey, he rose with dignity, let fall a few drops of holy water on the furious waves, and addressed the giant of the loch with words from an unknown tongue. It is believed that he ordered him, in the name of the first companions of our Saviour, who were boatmen and fishermen, to return the peaceful rule of the waters which Providence had bestowed upon them, to the boatmen and fishermen of Loch Long. At all events at the same moment the threatening spectre dissolved in flecks of brightness as light as those which the breath of the morning sends spinning on the invisible wave, and which could be mistaken from a distance for a cloud of eiderdown culled from the nest of the great birds which inhabits those shores. The vast surface of the whole bay froze; the very waves which rose

foaming against the beach did not sink down again; they lost their fluidity but retained their form, and the human eye, deluded to this day by the rounded outline, the sinuous movements, the bluish iridescent tone of the splintering breakers which give a rugged appearance to this shore, takes them from a distance for fields of living foam. Then the old holy man drew his bark up on the strand, in the hope perhaps that it might be found there by some poor mountain-dweller, pressed the crucifix upon his breast with his clasped arms, and strode firmly up the path in the rock as far as the cell which the angels had built for him beside the inaccessible eyrie of the white eagle. Several anchorites followed him into these solitudes, and gradually spread their pious colonies throughout the neighbouring countryside. Such was the origin of the monastery of Balvaig, and probably of the tribute which the gratitude, too soon forgotten, of the chiefs of the Mac-Farlane clan had long imposed for the benefit of the monks of this convent. It is easy to understand the secret link between the history of this ancient exorcism and its well-known consequences, and Jeannie's besetting thoughts. Meanwhile the shadows of an early night, at a season when the whole realm of day is over in a few short hours, were beginning to rise from the loch and spread up the surrounding heights, veiling the highest summits. Weariness, cold and long contemplation had exhausted Jeannie's strength and, seated listlessly at the stern of her boat, she was allowing it to drift from the swards of Argyll towards Dougal's house, when a voice from the opposite shore announced a traveller. The mere pity

aroused by a man stranded on a shore where his wife
and children do not live, and who is thus going to cause
them many hours of waiting and anguish, in the ever-
dashed hopes of his return, if the ear of the boatmen
should by chance be heedless of his prayer; the interest
which women above all feel for an outcast, a cripple, an
abandoned child, alone would have roused Jeannie to
struggle against the sleep which was overwhelming her,
and to turn her prow once more towards the whinn
which stands between the long bay and the hills. 'What
could drive him to cross the loch at this hour?' she
wondered, 'except the need to avoid an enemy, or to
join a waiting friend? Oh, may those who wait for the
ones they love never be disappointed in their hopes;
may they receive what they desire!...'

And the broad, peaceful waves multiplied
beneath her oar, which struck them like a scourge. The
cries continued, but so weak and intermittent now that
they sounded more like the moaning of a phantom than
the voice of a human creature, and Jeannie's gaze,
raised towards the shore, showed her but a dark
horizon whose deep stillness seemed unbroken by any
living thing. If at first she had thought she glimpsed a
figure leaning over the loch, and stretching beseeching
arms in her direction, it was not long before she saw
that in fact the supposed stranger was a dead stump,
waving two wizened branches piled with rime. If for a
moment she had thought she saw a shadow wandering
near her boat in the thickening mist, it was in fact her
own, which the last glow of twilight was projecting
upon the floating curtain, and which was becoming

increasingly merged with the vast shadows of the night. At last her oar struck the hissing stems of the reeds on the shore, and she saw an old man emerging from them, so bent beneath the weight of his years that it was as though his heavy head were seeking some support upon his knees! He kept his tremulous balance only by entrusting it to a fragile reed which nonetheless bore it without bowing; for this old man was a dwarf, and the smallest, in all likelihood, ever to be seen in Scotland. Jeannie's astonishment redoubled when, decrepit as he seemed, he leapt nimbly into the boat and sat down opposite her, in a manner which lacked neither suppleness nor grace.

'My father,' said she, 'I shall not ask you where you are bound, as the goal of your journey must be too remote for you to have any hope of reaching it to-night.'

'You are wrong, my child,' he replied; 'I have never been so close to it, and since I have been in this boat, it seems to me that it is well within my grasp, were we to be immobilised by eternal ice here in the middle of this bay.'

'That is extraordinary,' said Jeannie. 'A man of your size and age would be well-known throughout the region if he lived here, and unless you are the little person from the Isle of Man whom I have often heard my mother speak of, and who taught the inhabitants of those parts the art of weaving long baskets with reeds, from which the fish, held by some magic power, can never escape, I would say that you have no home on the coasts of the Irish Sea'.

'O my dear child, I had one, quite near these

shores, but I was cruelly dispossessed of it!'

'Then I understand the reason which brings you back to the coasts of Argyll. You must have left very fond memories behind you here, to leave the smiling shore of Loch Lomond in this season and at this late hour, bordered as it is with delightful dwellings, and stocked with an abundance of fish finer than those of our brackish waters, and a whisky more health-giving for men of your age than that drunk by our own fishermen and sailors. To return amongst us, you must surely love someone in this region of storms, which the very snakes abandon at the approach of winter. They slither towards Loch Lomond, cross it like a disorderly marauding clan, and seek refuge beneath the south-facing rocks. Fathers, husbands and lovers do not hesitate to approach harsh lands when they may hope to find there those to whom they are attached; but you surely could not dream of leaving the shores of Loch Long this night.'

'Such is not my intention,' said the stranger. 'I would rather die here a thousand times!'

'Though Dougal is parsimonious,' continued Jeannie, unable to abandon her train of thought, and having barely heeded the interruptions of her passenger, 'although it does not trouble him,' she added with a touch of bitterness, 'that the wife and children of Coll Cameron, who is less well-off than we, are better dressed than I at the clan gathering, still there is always barley bread and milk for wayfarers at his croft; and I would far rather see you drink up our good whisky than that old monk from Balvaig, who never comes to

our cottage but to do harm.'

'What is this you say, my child?' the old man broke in, affecting the greatest astonishment, 'the cottage of Dougal the fisherman was in fact my journey's end; it is there,' he cried, his trembling voice softening still further, 'that I shall look again upon all I love, if I have not been misled by treacherous information. Fortune has served me well in finding me this boat!...'

'I understand,' said Jeannie smiling. 'Thanks be to the little person from the Isle of Man! He always loved fishermen.'

'Alas, I am not who you think I am! A different emotion draws me to your house. Listen, my pretty one — for the northern lights which bathe the foreheads of the mountains, the falling stars which illuminate the whole horizon, the luminous trails of light which stream across the bay and sparkle under your oar; all this flooding, trembled brightness, reaching even this lonely boat, has enabled me to perceive that you are extremely pretty! Pray heed, then, when I tell you that I am the father of an elf who now lives with Dougal the fisherman; and if I am to believe what I am told, above all if I trust to your face and your speech, I would indeed be puzzled, at my age, had he chosen another dwelling place. I have known of this but for a few days and, for reasons I shall not elaborate upon here, I have not seen the poor child since the reign of Fergus. So imagine my eagerness, or rather my happiness, for here is the shore.'

Jeannie began to steer the boat away again, casting her gaze heavenwards and pressing a hand to

her forehead.

'What!' cried the old man, 'are we not going ashore?'

'Going ashore?' repeated Jeannie, sobbing. 'Unhappy father! Trilby is no longer there!...'

'No longer there! Who would have driven him away? Surely, Jeannie, you have not been callous enough to abandon him to those heartless monks of Balvaig who were the cause of all our misfortunes?'

'Yes, yes,' cried Jeannie in tones of desperation, manoeuvring the boat out again towards the Arrochar shore. 'Yes, it was I who was the cause of that banishment, thereby losing him for ever!...'

'You, Jeannie, so charming and so good! The luckless child! What sins he must have committed to have earned your hatred!...'

'My hatred,' continued Jeannie, letting her hand fall on to the oar and her head on to her hand. 'God alone knows how much I loved him!...'

'You loved him!' cried Trilby covering her arms with kisses (for this mysterious traveller was Trilby himself, and I am bound to admit that if my reader feels any emotion at all at this disclosure, it is probably not that of surprise!), 'you loved him! Ah! Say it once more! Dare to say it to me, to say it for me, and thus set the seal upon my ruin or my happiness! Accept me, Jeannie, as a friend, as a lover, as your slave, as your guest, or at least as you accepted this unknown passenger. Do not refuse Trilby a secret refuge in your home!...'

While thus speaking, the elf had cast off the bizarre disguise he had borrowed the previous night

from the Shoupeltins of Shetland. He abandoned his hempen hair and beard of white moss to the running tide, together with his collar of samphire and of seaweed, and his belt borrowed from the silvery bark of the birch. Now he was just the wandering spirit of the hearth, but darkness blurred his appearance, and Jeannie was reminded all too strongly of the singular tricks he had played in her latest dreams, of the seductions of that dangerous lover of her sleep who filled her nights with illusions at once so charming and so feared, and the mysterious painting in the monastery gallery.

'Yes, Jeannie,' he murmured, sweetly and softly, like the caressing air of the morning when it sighs across the loch; 'give me again free run of the hearth where I can see and hear you, that modest corner near the ashes which you would stir of a morning to awaken a spark. Ah! if truly necessary, Jeannie, I shall no longer importune you with my caresses, I shall no longer tell you of my love, I shall no longer brush against your dress, even should it float towards me, wafted in my direction by air or fire. If I do allow myself to touch it, even once, it will be to remove it from the encroaching flame, when you fall asleep while spinning. Indeed, Jeannie, since I see that my prayers cannot sway you, I ask you only to grant me a small place in the cattle byre. I can still gain a little happiness from this thought, I shall kiss the wool of your sheep, for I know you like to roll it around your fingers. I shall weave the most scented flowers in the manger to make him garlands, I shall throw myself upon the litter with more pride and delight than I would tread all the rich carpets of kings;

I shall utter your name in a low voice: Jeannie! Jeannie! ... and no one will hear me, of that you may be sure, not even the monotonous beetle which ticks in the woodwork at measured intervals, and whose death watch alone breaks the stillness of the night. All I want is to be there, and to breathe the air which has been near you, which has mingled with your breath, which has passed between your lips, which might tenderly have caressed you, if inanimate nature enjoyed the privileges of our own, if it had feelings and could love!'

Jeannie now saw that she had moved too far from the shore, but Trilby understood her unease and hastened to reassure her by taking refuge in the prow of the boat.

'Go, Jeannie,' he urged her, 'go back to the shores of Argyll without me, to those shores where I myself cannot venture without that permission which you do not grant me. Abandon poor Trilby to an exile in which he is doomed to the perpetual pain of your loss. All he can hope for now is a farewell glance in his direction! Unhappy Trilby, how deep is the darkness!'

A will-o'-the-wisp glimmered on the lake.

'There!' said Trilby, 'my God, I thank you, I could accept your malediction at this price!'

'It is not my fault, Trilby,' said Jeannie, 'I was not expecting that strange light, and if my eyes met yours... if I thought that you read in them the expression of a consent all of whose consequences, in truth, I did not foresee... As you know, there is another condition to Ronald's redoubtable sentence. Dougal himself must call you to his cottage. Furthermore, is your own

happiness not dependent on his refusal and my own? You are loved, you are adored by the noblewomen of Argyll, and in their castles you must have found...'

'The castles of the noblewomen of Argyll!' retorted Trilby. 'Oh come! Since I left Dougal's croft, though it was the beginning of the harshest season of the year, my foot has not touched the threshold of any man's abode; I have not warmed my numb fingers at the flame of any crackling hearth. I was cold, Jeannie, and how often, weary of shivering at the loch's edge, among the branches of the withered shrubs bent beneath the weight of hoar frost, have I not bounded up to the summits of the mountains to rekindle some remnant of warmth in my numbed limbs, how many times have I wrapped myself up in freshly fallen snow, and rolled in the avalanches, but diverting them so as to avoid harming any building, compromising the hopes of a crop, endangering any human being. The other day as I ran, I saw a stone on which an exiled son had written the name of his mother; touched, I hastened to divert the dreadful scourge, and I plunged with it into an abyss of ice where no living creature ever breathed. Sometimes, if the cormorant, frustrated at finding the bay imprisoned beneath the pane of ice which denies her the usual prize of her fishing exploits, had flown across it, mewing with impatience, to go and ravish an easier prey in the Firth of Clyde or the Sound of Jura, I would climb joyously into the perilous nest of the absent bird, and with no other concern than that she might shorten the duration of her absence, I would warm myself amongst this year's fledglings, still too

young to take part in her expeditions at sea. Soon
familiar with their clandestine guest (for I never failed
to take them some offering), they drew apart at my
approach to leave me a little space amongst them in
their downy bed. Or, in imitation of the industrious
field mouse which digs itself an underground burrow to
spend the winter in, I would cautiously remove the ice
and snow piled up in some little corner of the moun-
tain, exposed the following day to the first rays of the
rising sun; I would carefully lift the carpet of old moss
which had whitened on the rock over the years and, as
I arrived at the deepest layer, I would lap myself in its
silver threads like a child in its swaddling bands, and
fall asleep protected against the night wind under my
velvet coverlet; happy, above all, when I thought that
you might have trod this same ground when going to
pay your tithe of fish or corn. Such, Jeannie, were the
superb castles I dwelt in, such was the lavish welcome
I received since I have been separated from you, that of
the chilly cock-chafer which I have sometimes disturbed
unwittingly in the depths of its retreat, or of the bewil-
dered seagull forced by a sudden storm to take refuge
near me in the hollow of an old willow riven by age
and fire, whose blackened, ash-strewn cavities mark the
habitual moot of smugglers. That, oh cruel one, is this
happiness with which you reproach me. But what am I
saying? For in truth, that time of misery was not
without happiness! Although I was forbidden to speak
to you, and even to approach you without your per-
mission, at least I could follow your boat with my gaze,
and elves less severely treated than myself, sympathetic

to my woes, sometimes brought me your breath and your sighs! If the evening wind had blown the remnants of some autumn flower from your hair, the wing of an obliging friend would carry it through the air to my solitary rock, to the vaporous clouds where I was banished, and would let it fall upon my heart. One day, indeed, do you remember? the name Trilby died upon your lips; an imp seized it, and came to charm my ear with the sound of that involuntary call. Then I was weeping as I thought of you, but my tears of grief were turned to tears of joy...'

'Explain yourself, Trilby,' said Jeannie, who was trying to keep her emotions at bay. 'It seems to me that you have just told me, or reminded me, that you were forbidden to speak to me or approach me without my permission. That was indeed the sentence uttered by the monk of Balvaig. How is it then that you are here in my boat, beside me, known to me, without my having given you permission?'

'Jeannie, forgive me for repeating it, if this avowal costs you dear... you said that you loved me!'

'Whether as a result of seduction, weakness or a moment of pity, I made it,' agreed Jeannie, 'but before, but until then, I thought that the boat was forbidden to you, as was the croft...'

'I know that all too well! How many times I have tried in vain to call it to me! The air carried off my cries, and you did not heed me!'

'But what is the answer?'

'I do not know myself,' answered Trilby; 'unless perchance,' he continued in a humbler and less assured

tone, 'you confided the secret, which I discovered by chance, to benign hearts, to guardian friendships which, unable to revoke my sentence entirely, nonetheless succeeded in mitigating it?'

'I have told no one, no one,' cried Jeannie in alarm...'I myself did not know, I myself was not yet sure... and your name went from my thoughts to my lips only in the secrecy of my prayers...'

'Even in the secrecy of your prayers, you might move a heart which loved me, and if, in the presence of my brother Columban, Columban Mac-Farlane...'

'Your brother Columban! If, in his presence... your brother! O God of mercy!... have pity on me! Forgive me!'

'Yes, I have a brother, Jeannie, a well-beloved brother, who is now in Heaven and for whom my absence is but a painful interlude in a sad and perilous journey from which return is almost certain. A thousand years are but a moment on earth for those who are destined never to leave one another.'

'A thousand years — that is the term that Ronald set you, if you returned to the cottage...'

'And what are a thousand years of the harshest imprisonment, what is an eternity of death, an eternity of pain, for the soul whom you had loved, for the creature, all too favoured by Providence, which had been associated but for a few moments with the mysteries of your heart; for him whose eyes might find an answering look of abandon in your eyes, a smile of tenderness on your mouth! Ah! nothingness, Hell itself would hold but negligible torments for the happy lost

soul whose lips had brushed your lips, caressed the
black braids of your hair, touched your eyelashes, dewy
with love, and who, in the midst of those endless
torments, could tell himself for ever that Jeannie had
loved him for a moment! Can you image that undying
bliss? It is not thus that the weight of God's anger
crushes the guilty soul it wishes to punish!... But to fall,
broken by His powerful hand, into an abyss of despair
and regret where, throughout the centuries, the demons
repeat: No, no, Jeannie did not love you! That, Jeannie,
is a fearful thought, a desolate future!... So ponder
carefully: my Hell depends on you.'

'But Trilby, you must know that Dougal's
consent is needed for the accomplishing of your desires,
and that without it...'

'I will take responsibility for everything, if your
heart answers my prayers. O Jeannie!... my prayers and
my hopes!...'

'You are forgetting...'

'I am forgetting nothing!'

'My God,' cried Jeannie, 'do you not see... do
you not see... you are lost!...'

'I am saved,' answered Trilby, smiling.

'Look... there is Dougal.'

And indeed, at the end of a small promontory
which for a moment had hidden the rest of the loch
from her, Jeannie's bark was so near Dougal's that,
despite the darkness, he could not but have noticed
Trilby, if the elf had not hurled himself into the waves
at the very instant when the abstracted fisherman was
casting his net into the water. 'What have we here?' he

said, hauling it in, and disentangling from its mesh an elegantly shaped box of a precious material whose dazzling whiteness and silky smoothness he thought he recognised as ivory, encrusted with some bright metal, whose splendour was only heightened by the darkness.

'Do you know, Jeannie, that since this morning my nets have been constantly replenished with the most beautiful fish I have ever caught in this loch? And, as a crowning piece of good fortune, I have just hauled in a veritable treasure; to judge by the weight of this box and by the magnificence of its ornaments, it must contain nothing less than the crown of the king of the isles, or the jewels of Solomon. So hurry and take it back to the croft, and hasten back to empty our nets into the roadstead fishpond, for we must not be neglectful of lesser profits, and the fortune which St Columban is sending me will never make me forget that I am just a humble fisherman.'

For a time Jeannie moved as if in a daze: it was as though a cloud were floating before her eyes and obscuring her thoughts, as though, borne from illusion to illusion by a restless dream, she were so overcome by the weight of sleep and torpor that she could not awaken herself. Arriving at the cottage, she set the box down carefully, then approached the hearth, raked aside the ash, which was still hot, and was surprised to find some coals still alive, as after some festivity. The cricket was singing with joy at the mouth of his little domestic cave, and the mysterious box was still where it had just been placed, with its silver-gilt inlay, its rows of pearls and rosettes of rubies.

'I was not asleep,' said Jeannie. 'I was not asleep!' O wretched fortune,' she continued, sitting down at the table and letting her head fall upon Dougal's treasure. 'What do I care for the vain riches contained within this ivory casket? Do the monks of Balvaig think that this is the price they have paid for the loss of the hapless Trilby? For I cannot doubt that he has disappeared beneath the waves, and that I can never hope to see him again! Trilby, Trilby,' she sobbed.

She was answered by a lengthy sigh. She looked around her, listened to assure herself that she had not been mistaken. The sighing had ceased.

'Trilby is dead,' she cried. 'Trilby is not here! Furthermore,' she added with a certain glee, 'what advantage will Dougal gain from this treasure which he cannot open except by forcing the lock? How might one know the secret of the fairy catch which must turn upon these emeralds? Or of the magic secrets of the enchanter who constructed it? We shall surely have to sell our souls to some demon to penetrate its mystery.'

'All you need to do is to love Trilby and to tell him you love him,' said a voice from within the casket. 'Doomed for ever if you refuse, saved forever if you consent, that is my destiny: the destiny that your love has forged for me...'

'Tell him...?' said Jeannie.

'Tell him: Trilby, I love you!'

'Tell him that I love him... and the box would open? and you would be free?'

'Free and happy!'

'No, no,' cried Jeannie desperately, 'no, I cannot

117

tell him that, I must not tell him that!'

'And what might you have to fear?'

'Everything,' replied Jeannie. 'A terrible violation of my marriage vows... despair... death...'

'Foolish creature! What then can you think of me? Do you imagine, you who are all to the luckless Trilby, that he would torment your heart with a sinful passion, and pursue you with a dangerous insistence which would destroy your happiness, which would poison your life? You should think more kindly of his fondness! No, Jeannie, I love you for the joy of loving you, of obeying you, of serving you. Your avowal is but one more justification for my submission; it is not a sacrifice! In telling me that you love me, you deliver a friend and gain a slave! What parallel dare you imagine between the response that I am asking for, and the noble and touching obligation which binds you to Dougal? The love I have for you, Jeannie, is not of this earth; ah, how I would like to be able to make you understand that, in a new world, a passionate heart, a heart which has been deceived in its dearest affections in this one or which has been dispossessed of them before time, becomes capable of opening to an infinite tenderness, to an eternal happiness which can no longer be sinful! Still too earthbound, your senses have yet to grasp the ineffable love of a soul disengaged from all duty, and yet which can embrace all the creatures of its choice with a boundless affection without breaking faith! O Jeannie, you do not know how much love there is outside this life, nor do you know how calm and pure is that love! Tell me, Jeannie, just tell me you love me!

It is not so hard to say... It is only the expression of hatred that you should begrudge me. I, Jeannie, love only you! Indeed, my Jeannie, every thought of my being, every beat of my heart, belong to you! My breast is stirred when the air I move through echoes with your name! My very lips tremble and stammer and I seek to utter it! O Jeannie, how I love you! And yet you will not, you dare not say... Trilby, I love you. Poor Trilby, I love you a little...'

'No, no,' said Jeannie, fleeing in alarm from the room where Trilby's gilded prison lay. 'No, I shall not violate the vows I freely made to Dougal at the foot of the holy altar; it is true that Dougal is sometimes difficult and severe, but I am convinced he loves me. It is also true that he is unable to express the emotions he feels, unlike this fateful spirit who is bent on destroying my peace of mind. Yet who knows but that this lamentable gift might not be a particular manifestation of the power of the devil, and that it is not he who seduced me through the cunning converse of the imp? Dougal is my friend, my husband, the husband I would choose again. I have plighted my troth to him, and nothing shall triumph over my vows and my resolve! Nothing, not even my heart,' she added sighing. 'May it break rather than forget the duty God has enjoined upon me!...'

Jeannie had scarcely had time to strengthen her resolution, repeating it to herself with a determination that was all the more pronounced in that she had so much resistance to overcome. She was still murmuring the last words of this secret commitment when she

heard two voices beside her, below the short-cut she herself had just taken to reach the loch-side more quickly, but which could not be used when carrying any considerable burden. Dougal usually took the other, laden as he often was with the finest of his fish, particularly when he was bringing a guest to the cottage. The wayfarers were following the lower route and were walking slowly like men engrossed in serious conversation. It was Dougal and the old monk of Balvaig, led by chance to the opposite shore, and who had arrived in time to climb into the fisherman's boat and to ask him for hospitality. As may be imagined, Dougal was unwilling to refuse this to the holy guest of the monastery from whom he had that day received such great benefits, for it was to such influence that he attributed the return of the precious fish and the discovery of the casket, so often dreamed of, which must contain treasure far more valuable and durable. Thus he welcomed the old monk more eagerly even than on the memorable day when he had had to ask him about the banishing of Trilby, and it was his repeated expressions of gratitude which had struck Jeannie's ear. She stopped to listen, almost despite herself, for at first she had feared, without admitting it, that this journey had no purpose other than the ordinary Inverary collection which never failed to bring one of these emissaries from the monastery to these parts at this time of year. She held her breath, her heart beating violently. She was waiting for some word which would spell danger to the captive in the cottage, and when she heard Ronald saying, in a louder voice: 'The mountains are delivered of them, the

evil spirits are conquered: the last of all was banished on the eve of St Columban,' she felt a two-fold reason to be reassured, for she did not doubt Ronald's words.

'Either the monk knows nothing of Trilby's fate,' she said, 'or Trilby is saved and forgiven by God as he seemed to hope.'

Calmer now, she reached the cove where Dougal's boats were moored; she emptied the full nets into the fish-pond, wrung the water carefully from the empty nets to protect them against the morning frost, spread them upon the beach to dry and continued along the mountain path with that sense of calm which comes from the feeling of a duty accomplished, but whose accomplishment has cost nobody anything.

'The last of the evil spirits was banished on the eve of St Columban,' repeated Jeannie to herself. 'That can't be Trilby, for he spoke to me this evening, and now he is at the cottage, unless my senses were deceived by a dream. So Trilby is saved, and the temptation which he has exerted over my heart was but a trial for which he was not responsible, but which was probably visited upon him by the saints. He is saved, and one day I shall see him again; one day, certainly!' she cried. 'He himself has just told me so: a thousand years are but a moment on earth for those who are destined never to leave one another!'

Jeannie's voice had risen so that it could be heard around her, for she believed herself to be alone. She was following the long walls of the cemetery which, at that unaccustomed hour, is frequented only by beasts of prey, or at most by orphans who are there to mourn

their parents. But now a torch from within rose to the height of the walls of the cemetery enclosure, casting an eerie light upon the tall trunks of the nearby trees. The northern lights, which had been flickering over the northern horizon since sunset, slowly drew their pale veil across the sky and mountains, sinister and terrible as the light from a distant fire one cannot help to quench. The night birds, surprised in their furtive hunting, folded their heavy wings and tumbled, dazed, down the slopes of the Cobbler; the eagle cried out in terror from the summit of his rocks as he beheld this unaccustomed dawn which heralded no sunrise.

Jeannie had often heard tell of the mysteries of the sorceresses, and the ceremonies they held in the last above of the dead, at certain times of the winter months. Sometimes, indeed, when she was returning wearily to Dougal's roof, she thought she had noticed a certain leaping glimmer rise and fall; she thought she caught snatches of strange voices on the air, fierce yapping laughter, and also songs which seemed to belong to another world, so insubstantial and fleeting were they. She remembered seeing them, their wretched tatters stained with ash and blood, disappearing into the ruins of the rough enclosure, or wandering, like the blue and white smoke of sulphur devoured by flame, in the shadows of the woods or in the vapours of the clouds. Urged on by an invincible curiosity, she crossed the dread threshold she had never gone beyond, except by day, to go and pray at her mother's tomb. She took one step, then stopped. Towards the end of the cemetery, shaded only by the species of yew whose fruit,

red as the cherries tumbling down from a fairy's basket, attracts all the birds of the region; behind the spot marked for the most recent grave, which was already dug but still empty, there was a large birch-tree known as the TREE OF THE SAINT, because it was claimed that St Columban, when still a young man, and before he had entirely withdrawn from the illusions of the world, had spent a whole night there in tears, struggling against the thrall of his profane loves. Since then, the birch-tree had been an object of veneration for the people and, had I been a poet, I would have wished to preserve some memory of it for future generations.

Jeannie paused, lowering her head to listen intently; she took another step forward and listened again. She heard a two-fold noise like that of an ivory box breaking and a birch-tree splitting, and at the same time she saw the long reflection of a distant brightness running over the ground, whitening at her feet and spreading over her garments. Timidly she followed the illuming ray to its source: it ended at the TREE OF THE SAINT, and before this tree stood a man in an attitude of one uttering a curse, and another in an attitude of prayer. The first was brandishing a torch which bathed his pitiless but serene forehead in light. The other was motionless. She recognised Ronald and Dougal.

There was a voice, too, a toneless voice like the last breath of a dying man, a voice faintly sobbing out Jeannie's name, and vanishing into the birch-tree.

'Trilby!' cried Jeannie.

And leaving the graves behind her, she leapt into the pit which was surely awaiting her, for none can

escape their destiny.

'Jeannie. Jeannie!' said poor Dougal.

'Dougal?' Jeannie repeated, stretching her trembling hand towards him, and looking now at Dougal, now at the TREE OF THE SAINT. 'Dougal, my dear Dougal, a thousand years are nothing on this earth... nothing!' she repeated, raising her head with difficulty; then she let it fall, and died. Ronald, who had paused for a moment, continued his prayer where he had left it.

Many centuries had passed since this event, when the destiny of the traveller, and perhaps also some stirrings of the heart, led me to this cemetery. It now stands alone in the countryside, and the smoke from the tall chimneys of Portinacaple, on the same shore, rises a good four leagues away. The walls of the old enclosure have fallen into ruin; all that remains is the odd vestige, here and there, either because the inhabitants of the region have used their materials for new buildings, or because the swards of Argyll, encouraged by a series of unexpected sudden thaws, have gradually crept over them. Yet the stone on Jeannie's grave has been respected by time, by the elements, and even by man. The following words, traced by some pious hand, can still be read: 'A thousand years are but a moment on earth for those who are destined never to leave one another.' The TREE OF THE SAINT is dead, but several vigorous shrubs now crown its exhausted stump with their rich foliage, and when a cool wind blows between their green shoots, raising and lowering their thick fronds, a lively and tender imagination could

still hear Trilby's sighs wafting over Jeannie's tomb. A thousand years are so little for the possession of one's beloved, so little time to mourn!...